A–Z

OF

BARNARD CASTLE & TEESDALE

PLACES - PEOPLE - HISTORY

Andrew Graham Stables
&
Gary David Marshall

AMBERLEY

Acknowledgements

Our sincere thanks go to the people of Teesdale for their support and especially the Bowes Museum, Teesdale Mercury Archives and the Parkin Raine Collection.

First published 2020

Amberley Publishing
The Hill, Stroud, Gloucestershire, GL5 4EP
www.amberley-books.com

Copyright © Andrew Graham Stables &
Gary David Marshall, 2020

The right of Andrew Graham Stables &
Gary David Marshall to be identified as the
Authors of this work has been asserted in
accordance with the Copyrights, Designs and
Patents Act 1988.

ISBN 978 1 4456 9742 0 (print)
ISBN 978 1 4456 9743 7 (ebook)

British Library Cataloguing in Publication Data.
A catalogue record for this book is available
from the British Library.

Typesetting by SJmagic DESIGN SERVICES,
India. Printed in Great Britain.

Contents

Introduction

This book is not the definitive A to Z of Barnard Castle and Teesdale, nor is it a series of road maps to assist with your navigation of this astoundingly beautiful and historic region. But, we hope to bring you a selection of historical events, people and places that have helped to create the unique character of this fascinating area. It includes stories from the past, organised into alphabetical order and chosen because of our own interest in the subject or because we felt they were essential to the story, and we hope they feel essential to you too. Some are well known and some are a little less familiar, but all are a crucial part of the region's story. We will explore how a boy born to the premier Anglo-Norman family and founders of this English town became a king of Scotland, who in the end was forced to abdicate and was imprisoned in the Tower of London. Though the Norman castle is the reason the town grew up under its walls, the Roman crossing of the Tees and road towards Binchester have also been important to the area.

Some rarely seen artefacts from a now demolished church which is thought to be of Saxon origin will be explored and may define the origins of this town built along an old Roman road. With access to a treasure trove of old photographs and the archives

The market town of Barnard Castle, taken from the traditional Yorkshire side of the river.

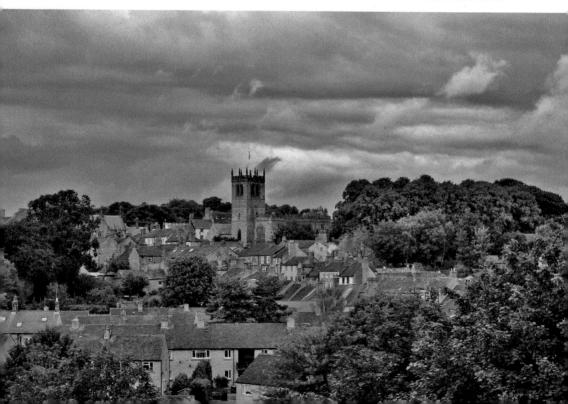

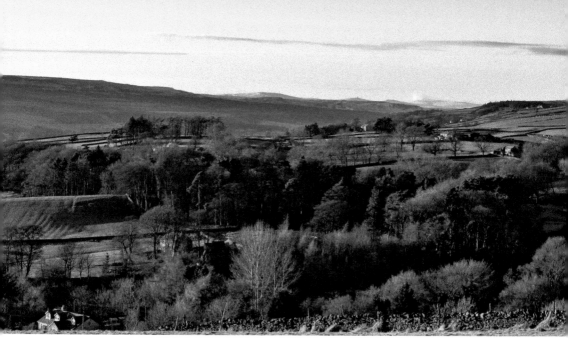

The beauty of Upper Teesdale.

of the impressive Bowes Museum, we will also reveal a new sketch of the town from the early 1700s by one of the renowned Buck brothers. The whole dale is considered an Area of Outstanding Natural Beauty and has recently been showcased by the film industry in a blockbuster award-winning war film. More than that, it is a place where people have lived and grown up, so a look at the social side of the area will be undertaken, and this will include an examination of some of the more unsavoury characters involved within this small Pennine town.

We hope you enjoy this exploration and trust you will discover something new, or revisit an old tale and get a sense of how proud we are to have been part of the story of this northern market town.

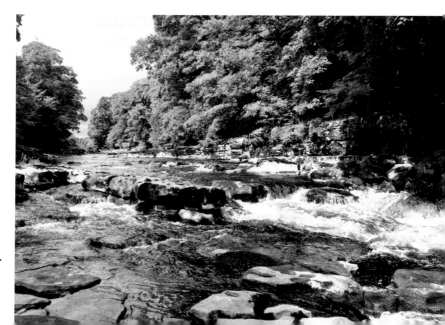

The River Tees
at Abbey Bridge.

Architecture

Joseph Kyle

Mr Joseph Kyle was born in 1818 and was to be one of the men responsible for the 'improvements in the architecture of the town'. As well as being the contractor responsible for the building of the Bowes Museum, he also oversaw the building of the North Eastern County School, the National School and the Masonic Hall on Newgate. Mr Kyle was a Freemason and was certainly responsible for a number of the 'stylish buildings' in the town.

Mr Kyle, it would seem, was a fractious fellow. In 1876, he was involved in a 'fist fight' with Frank Shields, also known as the Barnard Castle Hermit. Frank was not happy with the new building of the Bowes Museum and had conned his way onto the construction site. Frank had managed to make it to the roof before Mr Kyle and others finally subdued him.

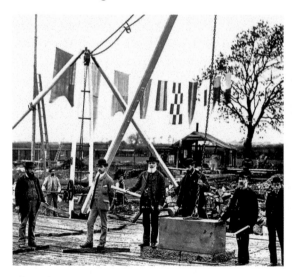

Above left: The Bowes Museum foundation stone laying in 1869. (Parkin Raine Collection)

Above right: Mr Joseph Kyle, responsible for many buildings in Barnard Castle. (Parkin Raine Collection)

The *Teesdale Mercury* reported that Mr Kyle had his 'whiskers pulled' by the hermit and he was led from the site, only to be taken to the Market Cross where the Town Guardians took him into the care of the town. Frank is recorded in the 1881 census as an inmate of Barnard Castle Poor Law Workhouse as a 'Gardener's Labourer (Dom) and Lunatic'.

It would appear this aggression ran in the family when his son Joseph Kyle junior was involved in a fracas at the same site in 1880. The headline 'Counter Charges of Assault at the Bowes Museum' describes a fight between Joseph Kyle junior and Richard Akers, who was an old servant of John Bowes. It turned out that Kyle's dog had chased Akers' cat. In retribution Akers had followed Kyle into the museum with a broom, warning Kyle not to let his dog chase his cat. It took other workers to break up the fight and the court case was later reported on by the *Teesdale Mercury*.

Mr Joseph Kyle died in 1897 as perhaps the most significant builder in the town's history, save perhaps the builder of the actual castle from which the town takes its name.

The Bank (No. 40–44), Old Manor House, Barnard Castle

This old building was once a manor house built around 1620 and is one of the oldest buildings in Barnard Castle. The original owners were the Shuttleworths, who included a high-ranking official who was appointed to oversee the dismantling of the castle for Sir Henry Vane of Raby Castle. To own a house of this stature, you would need to be in the pay of the local Lord. The Shuttleworths lived in this grand manor house that in those days was on Thorngate, as Thorngate once ran from the bridge up to Broadgates.

Though the historic façade is broken up by individual shopfronts, the manor house has Ionic columns set within the frame of the door. Some parts of the building are eighteenth century in tradition but the building is at least seventeenth-century with a fireplace dating to 1621. The fireplace was discovered during renovations in the 1980s when a false wall was removed to reveal the grand stone fireplace still with its original stone-carved surround. On a lintel were the initials M. S. and A. S. – probably the initials of Mr and Mrs Shuttleworth – and more fireplaces plus features of the original manor house were revealed, including the date of construction above a door in its original hangings – the date read 1621.

By 1746, the house was owned by a merchant by the name of Thomas Sandwick, followed in 1780 by another merchant of the town named Lancelot Bowser who was a cordwainer (an old name for bootmaker or shoemaker, usually with leather). The old manor house is also lamented in William Hutchinson's *History of Durham* of 1793. He mentioned a coat of arms above the door and other features that are lost to us today. He places the old manor house on the east side of Thorngate and sounds very sad about its loss; at the time of his writing, the manor house had been split into three buildings.

As we can see today the building is indeed split into three, and this is thought to have occurred around the 1750s. One of these buildings was used as an inn known as the Punchbowl *c.* the mid-1800s.

Dennis Coggins, an archaeologist from the Bowes Museum in the 1980s, suggested that the manor house was not the first building to stand on the site. A hard lime floor with traces of ash from a fireplace was discovered under the ground floor, which suggests the original building was probably built between the twelfth and fourteenth centuries.

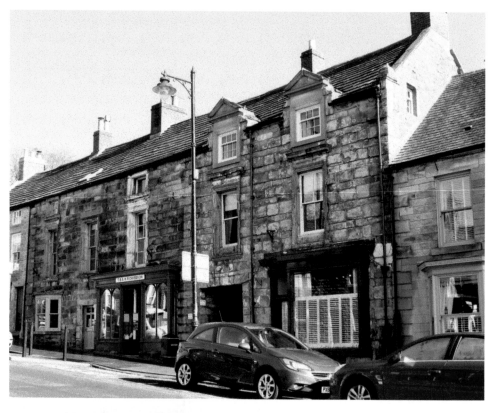

Above: The Old Manor House on the Bank.

Left: The Old Manor House doorway.

B

Bede Kirk

The next time you are walking along Harmire Road past the police station in Barnard Castle you may want to pause and think awhile, because until the late 1950s this was the site of possibly the oldest building in the town, even older than the castle. Here stood Bede Kirk (kirk meaning church in Old English), thought to be part of the medieval settlement of Marwood and mentioned by Symeon of Durham in his *Historia regum Anglorum et Dacorum* written in 1129. The Historia regum consisted of mainly copied manuscripts from before the Norman Conquest of 1066 and Symeon states that Marwood was part of the ancient parish of Gainford. Very little is known about Bede Kirk apart from that it was made up of at least some thirteen

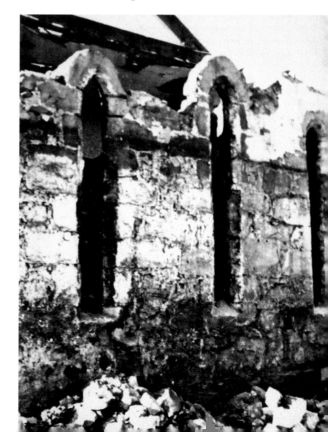

Bede Kirk during demolition with Gothic-style windows. (Parkin Raine Collection)

or more ecclesiastical buildings, of which nothing now remains. These buildings sat on top of the grassy knoll that remains today but with only vestiges of this complex remaining, including the road leading down from the police station.

In 1881 the Northumberland and Durham Archaeology Society visited Barnard Castle and Bede Kirk. The visiting party inspected the then farm buildings and in one found the positions of the piscina and of the three lancet lights in the eastern wall. They also noticed a fragment of a broken cross used in the built-up masonry in the existing west wall, and the opinion was expressed that 'the walls of the present building represented the original shell of the church as it existed in medieval times'. Therefore, towards the end of the nineteenth century very little remained of the church itself apart from its shell and some broken masonry.

It is thought Bede Kirk probably ceased to be a church by the time of Henry VIII. Leland, the travelling English antiquarian, makes no mention of the building on his visit to Barnard Castle during Henry's reign and in 1635 the land called Bede Kirk was in the occupation of one widow arrowsmith who paid no tithe at all, which is puzzling. As mentioned above, by the nineteenth century the building was a farmstead until its demolition in 1959 to make way for the police station that stands there today. There are no references to Bede Kirk itself other than the brief mention from Symeon of Durham almost 900 years ago, but the search goes on.

Though the Ordnance Survey first edition map dating to 1856–65 shows and names Bede Kirk, it is not known how it came to be named so. Therefore, it must be assumed

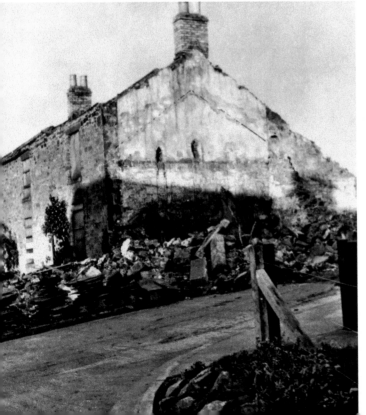

Bede Kirk during demolition between December 1958 and January 1959. (Parkin Raine)

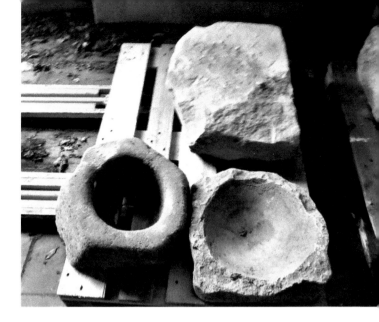

Anglo-Saxon font in storage.

it is named after the Venerable Bede, a seventh-century monk who may have a connection to Barnard Castle as well as Bede Kirk. It is possible that during the many raids by the Vikings on Jarrow, Whitby and the abbeys along the coast, Bede himself visited Marwood while travelling around the north-east of England. Indeed, there is a reference to Bede having travelled from the monastery at Jarrow and searching the North East to collect information for his works.

The Venerable Bede is often referred to as the father of English history and it is generally accepted that he gave us the idea of 'Angleland' or 'England' as we know it today. He wrote or translated some forty books on practically every area of knowledge, including nature, astronomy, and poetry, as well as the first 'martyrology' (a chronicle about the lives of the saints). He is probably best remembered for his work the *Ecclesiastical History of the English People*, which is regarded as the first real written history of the English people. He was born in the year 672 or 673 in the territory of the monastery of the blessed apostles Saint Peter and Saint Paul, which is at Monkwearmouth and near to Jarrow (originally part of Northumberland). From his own words, we know that he was given to the most reverend Abbot Benedict, and afterwards to Ceolfrid to be educated. Aged nineteen, he was admitted to the diaconate, and at the age of thirty he became a priest and appears to have spent his entire adult life at the monastery in Jarrow. He died in 735, at the age of sixty-two. He called himself Baeda, but soon after his death, one of his pupils sat down to compose an epitaph for his tomb. He had written 'Hac sunt in fossa Bedae ossa' or 'Here are in this tomb Bede's bones', but legend has it the next morning an 'angel' had filled the gap after the name of Bede with the word 'venerabilis' to become 'Hac sunt in fossa Bedae Venerabilis ossa', or 'Here are in this tomb Bede the Venerable's bones'. More likely is this title being used by Alcuin and Amalarius at the council of Aachen in 835 describing him as 'venerabilis et modernis temporibus doctor admirabilis Beda'.

In 1370, at the 'solicitations of one Richard', a devout monk of Barnard Castle, the bones of the Venerable Bede were moved from their location in Durham Cathedral and

placed in a casket of gold and silver, and then placed in a tomb shrine by the Bishop Pudsey in the newly built chapel of Galilee in the cathedral. Here they remained until the reign of Henry VIII and the Dissolution, when Henry ordered all the monastery and abbey's in the land destroyed including Bede's shrine. His bones were moved and reburied in the Galilee chapel's altar tomb under a slab of blue marble, which still stands today, on which a Latin inscription reads 'Here lie the bones of the venerable Bede' 'Here too near the grave of Bede repose the remains of Richard of Barnard castle'.

The connections do not stop there, for Hutchinson, Surtees and Fordyce all report on a house that appears as a religious building on the east side of Thorngate. It is possible that this building still does stand on Thorngate. Carved in one of the windows of this place is the inscription 'RICARDUS' and carved into a low archway that used to lead into the same premises are the words 'Broun. Abbat. "cuj"a"i"ep"picie-tur Deus' as well as a coat of arms on the front porch. These features were reported as fading in the late nineteenth century.

On the opposite side of Thorngate is another window that had 'Deo honor et gloria' inscribed, meaning 'Glory to God'. This window was destroyed in the rejuvenation of the area in the twentieth century. There is a possibility that these stone inscriptions were taken from Bede Kirk and recycled in various buildings around Barnard Castle.

Below left: Thorngate part of the old town.

Below right: Thorngate view to the Bank.

C

Crime and Punishment

The laws and charters concerning the town were upheld by the Lord of the Manor. Laws would have been enforced by the stewards and knights who represented the Balliol family. These men would have been housed in the castle and there were up to six manor-type houses in the castle to accommodate them. The castle was one of the largest in the north, including a castle farm, great and lesser stables, and various other buildings within its walls to support this centre of power. At the time 'might is right' was the basis of the law, all under the rule of God as dictated by the Roman Church. There were ecclesiastical courts and secular courts, the former used for religious issues and the latter for non-religious matters. Unwritten laws included a duel by combat where if you won your duel, then God decreed you were right and the culprit wrong, and vice versa, but if you were a peasant then the laws applied were harsh, without chance of any real justice.

It is recorded that the town gallows were on Cripple Hill on Galgate (the clue is in the name of the road) in the time of the Balliols, around where the pet shop is today, and marked the edge of the market and town in those days.

The Lord of the Manor continued to control the laws of the town even after the fall of the Balliols, and up until the seventeenth century justice was handled by the manor courts, which dealt with petty laws as well as court petty sessions. This was very similar to a modern magistrates' court, though if you were rich or a person of influence the laws worked very much in your favour. The poor were described as being 'at the mercy of the courts'. On Market Place, around where the public toilets are today, stood the old toll booth. Originally built to take the lord's tolls from the market vendors, it was also the centre of justice with the magistrates' court in the upper level of the building with cells on the ground level. Laws were upheld by 'constables', who were local men employed by the Lord of the Manor to police the weekly market, making sure tolls were paid, weapons were handed in, etc. The toll booth also included a forge, a meat market and slaughterhouse (a shambles). The town crier would announce court sessions and the names of those due in court from the front of the building. Plays were also performed in the upper room.

By the mid-1700s the toll booth was in a poor state of repair and was described as a 'tower of grim majesty'. The building of the new Market Cross and town hall (butter market)

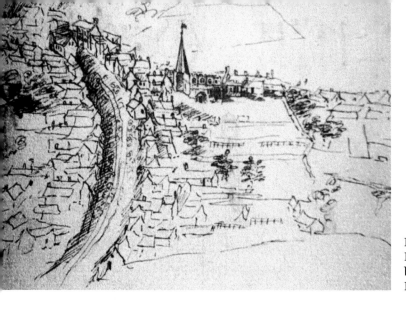

Buck sketch of the Bank including the toll booth. (Courtesy of the Bowes Museum)

meant business was slowly moved from the toll booth to the Market Cross, and the demolition of the toll booth in 1808 resulted in the transformation of the upper level of the Market Cross into a magistrates' court. A cell was added to the lower level, known locally as 'the black hole'. The building also held the town chest and all the charters.

It is around this time, after a number of burglaries on local merchants, that the Barnard Castle Watch was formed. Supposedly made up of the great and good of the town, the watch had its headquarters in the Market Cross. However, the watch did not last for long, as it was observed that instead of patrolling the town, the watch were enjoying a jolly good knees-up in the upper part of the Market Cross. A local man stated, 'rather than looking for wrongdoing, the lights shone bright in the Market Cross and there was the sound of revelry coming from within'. The watch was disbanded soon after. During the early part of the nineteenth century the court in the Market Cross saw some improvements made. The Vane family crest that had been removed from the old toll booth was fixed to the wall. The court also became more formal with the town crier announcement of court sessions being read from the south steps of the Market Cross. This ritual continued until 1842.

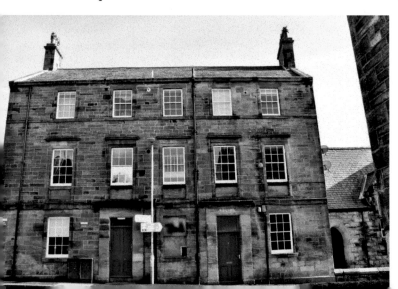

The old police station and magistrates' court, Queen Street.

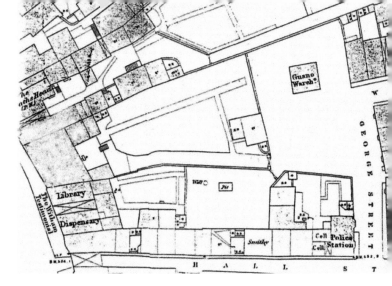

Map showing the old police station of Hall Street.

The first police station in Barnard Castle appeared very soon after Sir Robert Peel's Act of 1839, and it was on Bridgegate, the most densely populated area of the town. By 1851 Bridgegate was crime-ridden and notorious for immoral behaviour. At the Durham Assizes, a judge who sentenced a man who had assaulted a young woman and then had been hidden away from the police by locals in Bridgegate to avoid his arrest described the town as a 'sink of vice and profligacy'. He went on to describe how the defendant was a good example of the type of person who lived in the town. This may have been an unfair assessment of the locals, as it seems most crimes were committed by people passing through the town. This was a time of great change in the town with transient workforces building railways and later the reservoirs. There was also a frequent military presence when crime and particularly assaults on women grew in the nineteenth century.

The County Bridge area of the town had a notorious reputation for murder and the town itself had running battles and mass brawls on market day between the Hoolanders (Highlanders) or farmhands from upper Teesdale and the 'Tammy Weavers' (millworkers) of Barnard Castle. 'Barneys' in the street were a daily occurrence. One visitor from Darlington wrote of Bridgegate becoming a no-go area for the middle and upper classes.

As the cells of the Bridgegate police station and Market Cross were increasingly full, a new police station was needed. In around 1861 a large house on Queen Street, actually built in 1827, was taken over and became the town police station. The building was modified to include a magistrates' court and two cells. A holding cell and exercise yard were added later at the rear of the building. A map of 1855 shows a police station at the back of the Witham Hall, which must have made way when the music hall was added in 1860 and may have been used as a transition between Bridgegate and Queen Street. The Queen Street station remained in use for over a century until the new building at Bede Kirk was built in 1977. The magistrates' court remained at Queen Street until the end of 1998, when the sessions were moved to Bishop Auckland and Newton Aycliffe.

The Bede Kirk station was itself replaced by a new Quad Hub in 2017 when the fire, police, ambulance and mountain rescue services were combined in one building on Crook Lane.

Lady Devorgilla

Devorgilla, born around 1210, was the daughter of Alan, Lord of Galloway, and his second wife, Margaret of Huntingdon, a great-granddaughter of King David I of Scotland. She was to become one of the most powerful women of her time, as the mother of one Scottish king and the grandmother of another. She established a new Cistercian abbey near Dumfries and was instrumental in the founding of a college for the poor of Oxford.

At the age of thirteen, Devorgilla was married to John de Balliol, whose extensive family estates were in Picardy, Northumberland and South Durham. The Balliols held the lordships of the Teesdale and Marwood forests (this meant subject to forest law, which protected beasts of the chase from being hunted by anyone except the king unless given permission) and manors of Gainford, Middleton, Long Newton, Sadberge, but most importantly the stronghold of Barnard Castle. Though they would

The County Bridge over the Tees.

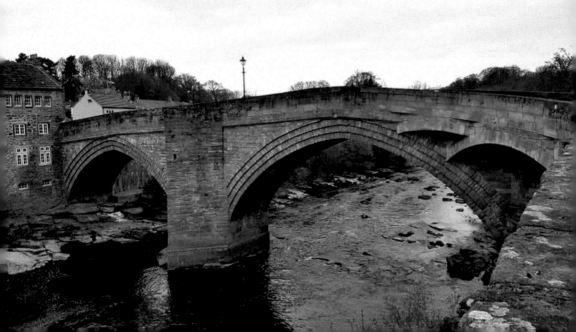

have travelled to and from various estates, a significant number of their nine children were born at Barnard Castle, and this seems to have been their principal residence.

Before 1263, John was involved in an ongoing land dispute with Walter Kirkham, the Bishop of Durham, and is supposed to have offended the bishop, who was an enormously powerful figure. John was adjudged to be in the wrong and had to make penance, part of which took the form of founding a college for the poor at Oxford University. Though the college was established, John died in 1268, and though it is not known where, his heart was removed and embalmed. Lady Devorgilla kept it with her in an ivory box with enamelled silver trimmings. She seems to have devoted the rest of her life to her children and to ensuring her husband was remembered. She put Balliol College on a more secure footing when in 1282 she made a permanent endowment to the college and established a code of statutes, a seal, and a house to study in that remains in place to this day. Before this, in 1273 she signed a charter to establish a new Cistercian abbey close to Dumfries called New Abbey.

After Lady Devorgilla's death in 1290 she was buried in the sanctuary of the abbey church, her husband's heart buried with her. Thereafter the monks chose to call the abbey Sweetheart Abbey in tribute to their love and devotion to each other. She was buried in front of the high altar and a stone slab in the floor marks the likely site of her burial. The graves are now lost amongst the ruins of the abbey, which is described as a 'shrine to human and divine love'.

Balliol College at Oxford University claims to be the institution's oldest college, and though born from a lord's hubris, still survives because of a lady's piety and desire for the family name to be remembered.

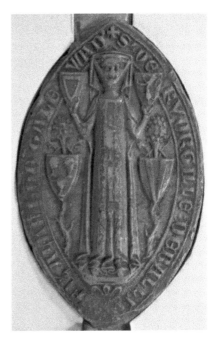

Lady Devorgilla seal.

Eggleston Stone Circle

William Hutchinson wrote in his *History of County Durham* (three volumes, 1785–94) of 'a mile to the north of the village of Eggleston, above a little brook, stands an ancient monument, called Standing Stones, represented in the cut'. He describes them as 'a uniform circle of rough stones, with an inward trench, and in the centre a cairn; much of the materials have been taken away to repair the roads. At a small distance, and close by the brook, is a large tumulus, crossed from the east to the west by a row of stones.'

Stone circles do occur in other parts of the world but predominantly in the British Isles and Britany, dating from as early as the Late Neolithic (3300 BC) to the Late Bronze Age (900 BC) and can be a variety of shapes and sizes. There are a number of suspected monuments in Teesdale, including Eggleston, Barningham Moor, Lunedale and Bowlees, plus another in Weardale at Westernhopeburn. These are not large stone circles like Stonehenge or Castlerigg but would have been just as important to the communities that built them.

Most of the stone circles are near watercourses, streams or pools, suggesting that water was of particular spiritual significance to our ancestors. Other theories include

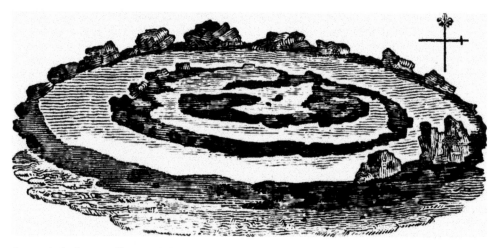

Stone circle from William Hutchinson's *History of County Durham.*

that they are sites of chieftain burials, early astrological sites understanding the seasons or mark the way for different groups of people. Our ancestors must have had an understanding of the world around them, as well as an understanding of engineering. Some stones were brought from other regions because of differences in colour or make-up and were heaved into position, even though they would have weighed several tons.

Eggleston stone circle is now practically lost and may have been the most significant stone circle in the south Durham area. Probably located on a route way between Teesdale and Weardale, it is a shame 'much of it has been removed to repair roads'. This practice of removing parts of the stone circle continued and by the mid-nineteenth century there was very little left.

A Geographical survey carried out in 2001 by the University of Durham Archaeological Services revealed features such as a circular ditch and a circular arrangement of ditches that once could have supported standing stones. Other features are abundant in the Teesdale landscape including numerous cup- and ring-marked rocks and the Tumulus of Eggleston impressive Kirk Carrion.

Fascist Meeting at Witham Hall

On a dark December night in 1934 one of the most notorious traitors in British history came to Barnard Castle and gave a speech to an audience of local people in the upper reading rooms of Witham Hall. Professor William Joyce was a New York-born son of an Anglo-Irish family who during the Second World War was known

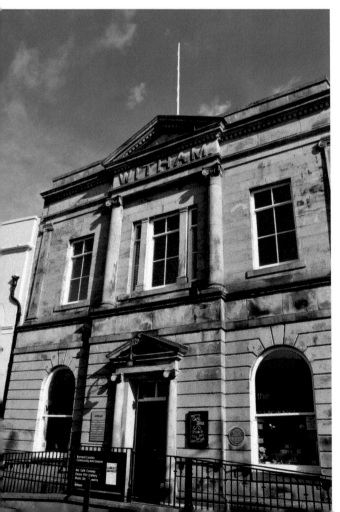

Witham Hall.

as Lord Haw-Haw. He had been a member of the British Union of Fascists (BUF) under Sir Oswald Mosley and became a leading speaker praised for his power of oratory. In 1934 he was promoted to the BUF's Director of Propaganda, was one of the leading advocates of Fascism in Britain and was a follower of Hitler. So much so that at the outbreak of the Second World War he defected to Berlin, though it is also possible he was about to be arrested by the government. He went on to broadcast Nazi propaganda over the radio to the British people.

'Germany calling, Germany calling' was the phrase that sent shivers down the spine of anyone who heard him speaking over their radio set. He was eventually captured and hanged as a traitor on 3 January 1946, making him the last person to be executed for treason in the United Kingdom.

The speech on that December evening at Witham Hall was given to an audience of over sixty people. Joyce talked about the benefits of the Fascist movement and he was accompanied by two 'Black Shirts', or bodyguards, as he was still sporting a scar from a previous knife attack by a communist. It seems he may have had some support as the *Teesdale Mercury* reported him receiving applause during his 'evoking speech':

> He held his hearers quite entranced by his oratory, and occasionally evoked applause as he touched on relevant points including unemployment, and care of the unemployed and ex-servicemen who were still suffering from the experience of the first war. He remained wonderfully cool while dealing with his subject.

There is an account of Lord Haw-Haw during one of his notorious broadcasts during the war talking about The Bank in Barnard Castle being in flames from Luftwaffe bombing. Of course, it was all falsehoods and propaganda used to strike fear in the hearts of the British people.

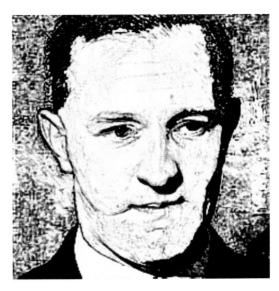

Pencil sketch of William Joyce, aka Lord Haw-Haw.

Galgate and Gallows

Galgate, Gallgate, or Gallowgate is a broad street or suburb of Barnard Castle which runs from east to west. According to some authorities, the ancient town of Marwood stood here before Barnard Castle was built. The street is supposed to derive its name

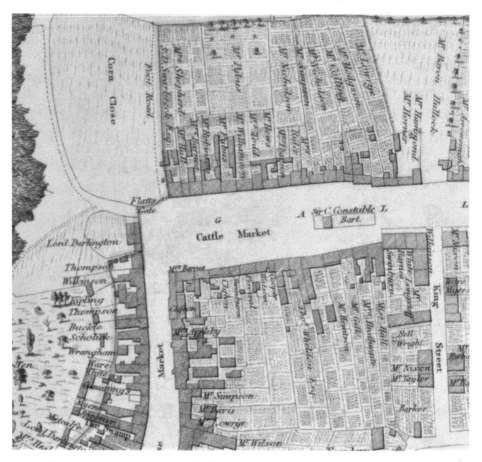

1827 map by Woods showing unidentified building in Galgate.

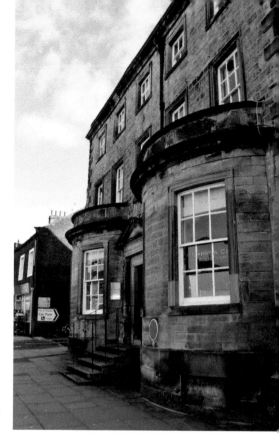

This Galgate house was for a time the council offices and the home of Sir Robert Murchison, geologist and explorer as well as president of the Royal Geographical Society.

from having been the place of execution belonging to the lordship. The Balliols had the 'right of markets and fairs, pillory and trumbel, gallows and 'infangenethef', which is the right to prosecute thieves within his lands and to confiscate their goods. He may have also held 'outfangenethef, which is the right to pursue a thief outside his own jurisdiction, bring him back to his own court for trial, and keep his forfeited chattels on conviction.

Spearman, who wrote in 1729, says, 'The place of execution of felons is at this day apparent; and the trials of matters of right were there (at the castle) till 26th year of King Henry VIII, that it was enacted that all felons should be tried by the king's commission; since which time the felons have been tried at Durham, to save the king's charges of justices coming to Barnard Castle.'

Though the gallows of Barnard Castle may have remained unused since c. 1535 during the rule of Henry VIII, only a few years later following the rebellion against Elizabeth I in 1569, Sir George Bowes presided over the executions of around 600 of the rebels including twenty in Barnard Castle. There is also reference to a 'Cripple Hill' in Galgate and a property in the middle of the street belonging to Francis Tunstall of Wycliffe. The 1827 map by Woods shows a building in the middle of Galgate owned by Sir Christopher Constable Baronet, who was resident at Wycliffe Hall, and may have been the old gallows or pillory. Near the summit of the A66 opposite Boldron is a road named Gallow Hill and this may represent the position of an old gallows or gibbet to warn travellers to stay within the law.

The wide street of Galgate now.

Galgate looking south-west showing the alignment with the old Roman road to Bowes.

Below is a list of executions at Durham relating to Barnard Castle and Teesdale:

1803: 13 August, John Moses, for stealing drapery goods from the shop of Benjamin Jackson at Barnard Castle.

1822: 9 August, Robert Peat, aged fifty, of Ravensworth, near Richmond, for poisoning a relative named Robert Peat, at Darlington, whose will he had stolen. Laudanum in his broth and stolen his will.

1848: 25 March, William Thompson, for the murder of John Shirley, head whipper-in (assistant to huntsman) to the Duke of Cleveland, near Barnard Castle, on 2 February.

1875: 2 August, William McHugh, sentenced to death at Durham Assizes on 13 July for the murder of Thomas Mooney at Barnard Castle.

1880: 16 November, William Brownless, for the murder of his sweetheart, Elizabeth Holmes, at Evenwood, near Bishop Auckland, on 18 August.

1884: 27 May, Joseph Lowson, for the murder of Police-Sergeant Smith, at Butterknowle, 23 February 1884.

1908: 5 August, Matthew James Dodds (forty-three), joiner, for the murder of his wife, Mary Jane Dodds, at Hamsterley, in February 1908.

2/2/2

THE

FOLLOWING LINES

Have been lately written on the horrid and brutal

MURDER,

committed by three young men named Breckon, Raine and Barker, residing in the Town of

Barnard Castle,

in the County of Durham, on the bodies of Joseph Yates and Catherine Raine, by drowning them in the river Tees, on the evening of the 9th Aug., 1845.

Good people all who stand around, I pray you now draw near,
Unto these lines that I have penn'd, I hope you'll lend an ear,
It is concerning of this dreadful deed, that has lately come to
 light,
A more horrid crime ne'er yet was done on a dark and dreary night.

CHORUS.
So let us all take warning from this young couple's fate,
And never wander from your homes, on a dreary night so late.

On the Yorkshire side of the river, this murderous deed was done,
Near the town of Barnard Castle where this youth he then was
 drowned,
The unfortunate female was thrown over the Bridge and shared his
 horrid fate,
Whilst their murderers it now being midnight, did homewards then
 retreat

It was in the month of August in the year of forty-five,
When those young and unfortunate pair were last seen there alive,
It was evening of the ninth, he met his sweetheart there,
But neither had any notion then, their death it was so near;

Accompanied by a female friend they quickly took their way,
Little thinking, in the foaming tide they soon were doom'd to lay;
As they proceeded towards Tramwell, at the corner of the street,
It was their misfortune then, their murderers for to meet,—

Between Barker then and Yates a dispute did quick arise,
When Yates he was severely struck, by Barker, on the eyes,
And after that they had him beat, and of his money was depriv'd,
They then did plunge his body into the foaming tide;

As soon as they had done this crime, to the Bridge they took
 their way,
When Catherine Raine, then did vow she would information lay;
But they were resolved that she should not cause any further strife,
Then over the Bridge her body they threw and deprived her
 of life.

When the young woman Humphrey saw this second murder done,
She on her bended knees did beg for mercy to be shown,
The murderers by a solemn oath, they did her life then spare,
That the secret she should keep, which she has done for a year.

Above eleven months the secret she did keep,
Which preyed severely on her mind, which deprived her of sleep;
On the 27th. of July, she resolved her mind to ease,
Then to the justice she did unfold the whole of the dreadful case.

Let us hope their souls are happy now, in heaven amongst the blest;
While their murderers now remain on earth, deprived of their rest,
For the Almighty God who reigns above, his vengeance will send
 down,
Upon those wretched criminals who may dread their dreadful doom.

Murder in the dale.

Hilton, Abraham

On a cool afternoon in October 1902, a hearse passed the Kings Head Hotel followed by eight mourning coaches containing the domestic servants, executors, personal friends, tenants and neighbours of the deceased. The procession passed through the town as the bells tolled from St Mary's Church. Hundreds lined the route as they passed down The Bank to Bridgegate, with the poor stood especially reverently, anxious to pay their last respects to the memory of a charitable man. The cortege headed to Cotherstone where a large body of mourners awaited the arrival. The hearse stopped as close as possible but the coffin was carried a few hundred yards to the grave, around which around 200 mourners had gathered. The coffin was of plain oak and on the breast-plate was a simple inscription: 'Abraham Hilton, died October 1st, 1902, aged 87 years.'

Abraham Hilton was said to have been born in a thatched cottage in Bridgegate on 15 April 1815, though after his death this fact was debated at length and it was ascertained that Mr Hilton was born in the last house of the Grove in Galgate. At that time the four houses above King Street and below King Street were not built, and from Grove Park to Mr Hilton's garden was a field, called 'Gip Gap'.

Abraham Hilton was a great philanthropist but nonconformist in his beliefs and was once quoted as saying, 'If the church spent less on pomp and circumstance and more on helping the poor, the world would be a much better and happier place.'

As a young man he was labelled as 'of delicate health' and because of this it is said he would go for a 4-mile walk every morning along the Barnard Castle Moor Road, and round by Broomielaw, before returning to the town. Apparently, he would take his exercise in all weathers, even when there was snow, and he 'always ate his porridge and milk'.

His ancestry has been linked with the old baronial family called Hylton who held great sway in the north of England and one branch had the manor of Hilton, which still stands near Staindrop. The family may have held the appointment of Steward of the Manor of Barnard Castle for a time and adopted a business as spirit merchants in the town. One member of the family was in the habit of bathing every morning in Percy Beck, even breaking ice to take a refreshing plunge – the *Teesdale Mercury* of 1902 said the pool was still known as 'Hilton's Hole'.

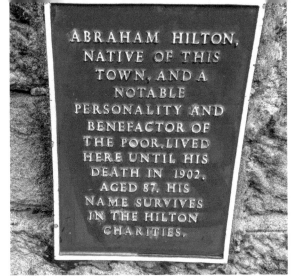
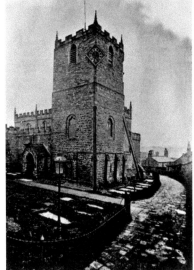

Above left: Abraham Hilton plaque.

Above right: St Mary's Church where the bells pealed for Abraham Hilton, shown before the restoration of the tower. (Parkin Raine Collection)

One of his ancestors was Cuthbert Hilton, a bible clerk who married people on the County Bridge and was described by his contemporaries as the man that 'used to entangle certain sons and daughters of iniquity into an illegal marriage upon Barnard Castle bridge, in the middle of the river, between the County Palatine of Durham and Yorkshire, where the Lord Bishop's writ does not run'.

Hilton succeeded to property and an old established business as a tea dealer and spirit merchant, in which he was well known from South Durham to the Yorkshire Dales. Not only was he industrious in business, but he was interested in science and philosophy. He was an amateur printer, painter and blacksmith, but also played the violin and was at one time the leader of the Barnard Castle Choral Society. Hilton was described as a man of purpose with 'no other object in view than the good of his fellow-creatures'.

His house still stands in Galgate and is honoured with a blue plaque. He was a man of great charity, who would help his fellow man, throwing pennies to the children or feeding the starved. It was reported that to his maid, who stood at the bedside, this courageous and undaunted debater lovingly whispered, 'Mary, are you there? Don't leave me' as his last words.

Though he gave generously to charities in his lifetime, he still left an estate with a value of £28,858, equivalent to more than £2million today. Much of this wealth was used to provide pensions for needy men and women, but the first four pensioners were his own servants, named Thomas Robson, Emma Wright, Jane Wright and James Aislaby; the fifth was Sarah Gibson, who could live for the rest of her life in a house he owned in Bowes. Those assisted by the will were not just from Teesdale but also Caldwell, Eppleby, Melsonby, Middleton Tyas, Barton, Reeth and the upper part of Swaledale.

Abraham's charities included the Bowes Cross Charity and the Three Chimneys Charity, which still continue to this day as the Hilton Charities. They provide services for the prevention of poverty, especially to the elderly in the area.

Inns, Taverns, Hotels and Public Houses

Bridgegate and Thorngate

Oddfellows Arms

One of the last remaining buildings from 'old Bridgegate' is the Oddfellows Arms, known to have existed in 1827. The nickname given by the soldiers stationed around the town was 'the claggy mat', but in the 1990s it was closed and converted to a private residence.

Landlords:
1834 – Thomas Barker
1865 – Robert Borrowdale
1881 – Margaret Harris
1894 – John Walker

The White Swan

This pub was first recorded as the Black Swan in 1783, before changing its name to the White Swan sometime before 1827; it was forever nicknamed the 'Mucky Duck'. In the nineteenth century it was notorious for ladies of the night and for a period during the mid-twentieth century it was known as the Castle Arms. This pub is located on the old Yorkshire side of the County Bridge and for a time had later licensing hours than the Durham side of town. The building was converted into residential premises in the early twenty-first century.

Landlords:
1827 – James Thompson
1834 – listed as the Swan
1847 – George Raper
1865 – Thomas Rutter

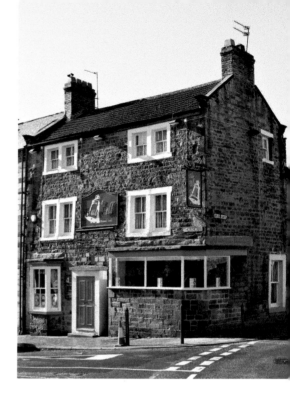

The Blue Bell.

The Blue Bell Hotel
The first record of the Blue Bell is in 1817. During the Second World War it was known as 'Dougies Gym' and unluckily a tank crashed into the building.

Landlords:
1847 – George Thompson
1865 – Chris Herbert
1875 – Robinson Cornforth
1894 – John Thompson Jr

Lambton Arms
In 1892 the Lambton Arms, which was next to the Blue Bell, was absorbed to become part of the Blue Bell.

Landlords:
1817 – First record
1827 – Mathew Harwood
1828 – Elizabeth Hales
1834 – Hutchinson Coulton

The Bridge Hotel
The Bridge Hotel was closed after the redevelopment of Bridgegate and Thorngate. It was said to be one of those pubs where you never let go of your drink, as it was common for it to be 'borrowed' while you were not looking.

Landlords:
1881 – Joanna Borrowdale
1889 – George Porter or Potter
1945 – Mrs Olive Gregory

Travellers Rest/Beehive, No. 34 Bridgegate
In 1861 the Travellers Rest was renamed the Beehive. In 1910 it was demolished during road widening on Bridgegate.

Landlords:
1847 – James Carnell
1861 – Travellers Rest renamed as Beehive
1881 – Thomas Dobson

Weavers Inn/Grey Hound Inn, No. 31 Bridgegate
In 1861 the Weavers Inn was renamed Grey Hound, and in 1958 a local paper announces its demolition.

Landlords:
1894 – Robert Robson

The Wellington/Oak Tree Inn, Bridgegate
The Wellington was renamed the Oak Tree in 1847, and in 1855 it was listed as a beerhouse.

Landlords:
1827 – Hannah Westwick
1834 – William Collinson
1847 – William Collinson
1865 – Elizabeth Dawson
1881 – Charles Hunton
1892 – Mr Hall
1894 – John Thomas Chatt

Royal Oak, No. 10 Bridgegate
1813 is the first recorded date of this establishment.

Landlords:
1827 – Thomas Alderson
1834 – Charles Alderson

Railway Tavern, Bridgegate
Landlords:
1865 – John Hunter

Boars Head, Thorngate
Landlords:
1817 – Dorothy Coats

The Bank

The Old Well
This building has had several names including Freemasons Arms, Masons Arms (1828), Ship Inn and the Railway Hotel. Sometime after the Second World War it was renamed the Old Well following the discovery of an old well in the backyard connected to the castle's history.

Landlords as Freemasons arms:
1827 – John R. Davies

Landlords as Ship Inn:
1834 – William Baker
1847 – Peter Dent

Landlords as the Railway Hotel:
1855 – Peter Dent
1889 – Mrs Bainbridge
1897 – George Airy

Below left: The Old Well.

Below right: The old Shoulder of Mutton, now residential.

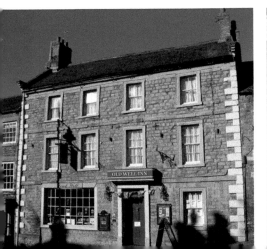
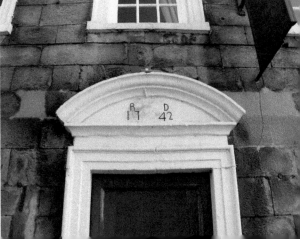

The Shoulder of Mutton

This pub was nicknamed the 'Bucket of Blood' after a tale of a landlord who threw a bucket into the well to draw water and pulled up a bucket of blood instead. Upon inspection of the well, it was found that one regular customer had fallen down the well and died. The nickname was forgotten about until a soldier in the Second World War found out about the story and the name stuck again. It is said the building is also haunted – could it be the customer from the well? 1742 is the date on the lintel above the door, and 1827 the pub was recorded as Shoulder of Mutton.

Landlords:
1834 – Harkner & Pickering
1847 – J. Loftus
1853 – John Nevison
1856 – Thomas Oliver
1865 – Thomas Hedley
1894 – Edward Robson
1897 – Edward Robinson

Blagraves

Blagraves is the oldest building in the town apart from the castle and St Mary's Church. The name comes from the Blagraves family, who purchased the building in the seventeenth century. A crest on the woodwork of a first-floor ceiling bears the initials W. I. B., commemorating a wedding in the year 1672. However, the building itself is

Below left: Blagraves and Shoulder of Mutton next door.

Below right: Old entrance to Blagraves.

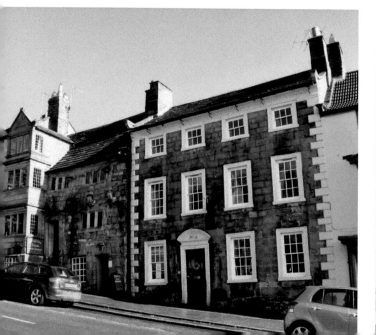
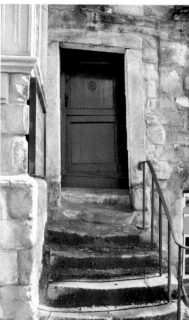

thought to be much older, with the foundations dating back to the time of the Balliols, and a cellar and stairs leading to what looks like a dungeon. There is a well in the basement and there is a long-held story of a tunnel that leads to Egglestone Abbey or the castle.

At the time of the 'Rising of the North' during the reign of Elizabeth I, the building was a public house known as 'The Boars Head', and apparently the cellars made an excellent brewery, with its water from the well making the finest-tasting ale.

There are also links to Richard III and his henchman, suspected of the murder of the two princes in the Tower of London. Blagraves was given by Richard to Joan Forest, wife of Miles Forest (Keeper of the King's Wardrobe) and a grant issued in September 1484 states, 'A Grant for life to Joan Forest Widow to the Kings servant Miles Forest and Edward her son an Annuity of five marks from the issue of the Lordship of Barnard Castle.'

In one of the walls of Blagraves there is a boar passant – the personal emblem of Richard III.

Christopher Sanderson Esq. of Eggleston recorded in his diary an important event from 1648, when a group of local officials were deputised to meet Oliver Cromwell, who was returning from Newcastle. He rode into Barnard Castle and held council at Blagraves, where he was entertained with oat cakes and burnt wine. Apparently, he took offence when he noticed his sleeping quarters contained Royalist crests on the walls and demanded them covered over. He stayed one night before riding on to Richmond.

The removal of plaster in the attic revealed inscribed religious text during one refurbishment and during the early part of the twentieth century the building became a 'House of Mystery' known as Cromwell House and contained a little town museum. Mr Victor M. Walton added four gargoyle musicians to the front of the building in the 1920s, but over the following years it suffered financial difficulties. Luckily it survived and today is a very pleasant restaurant.

The Burns Inn

The Burns Inn steps were notorious and claimed the lives of at least three people, the most famous of which was the Barnard Castle Hermit, Francis Shields, who slipped and fell on the steps in 1881 and died of his injuries. The inn lasted up until the 1950s when the landlord was Max Gaskin.

Landlords:
1858 – J. Benson
1894 – George Hoker Evans

Boars Head

Landlords:
1827 – Dorothy Carter
1847 – John Thompson

1865 – Thomas Longstaff
1889 – John Porter

The New Bridge Inn
Landlords:
1894 – Charles Whip

The Spirit Vault
Landlords:
1865 – one recorded owner, Thomas Carnell

Stags Head
Landlords:
1847 – Thomas Bainbridge

Douglas Arms
Landlords:
1894 – John Smith

Market Place and Horse Market

The Kings Head
Possibly built as a hotel in 1680. Next door to the Kings Head there used to be the Rose & Crown, which was demolished in 1878 and the Kings Head was extended into the space. The Kings Head had an excellent reputation as a coaching house and Charles Dickens spent 1 and 2 February 1838 here while collecting material for his novel *Nicholas Nickleby*. The archway was once the main entrance to the castle. The Kings Head closed in the late 1990s and became a care home.

Landlords:
1827 – Ann and Jane Harrison
1834 – Ann Harrison
1847 – Richard Harrison
1865 – Jane Ewbank
1894–1906 – Mrs Martha Jane Smith
1938 – Fred Dawson

Rose & Crown
Landlords:
1827 – James Donkin
1847 – Isabella Donkin

Red Lion
The Red Lion existed until the 1960s, when it was demolished, and is now a pizza shop.

Landlords:
1817 – Peter Crosby
1827 – Peter Crosby
1834 – James Errington
1847 – George James
1855 – Mrs Todd
1857 – Mrs Heslop
1865 – William Graham
1881 – Francis Porter
1889 – Mrs Thompson
1894 – Thomas Wilson
1897 – Thomas Wilson
1930s – Mr Jackson

Angel Inn
The Angel lasted until the twentieth century and the last landlord was called Canny Ayton. The building was pulled down and became Woolworths until this closed and became a frozen foods outlet.

Landlords:
1817 – Thomas Tunstall
1827 – Thomas Tunstall
1834 – Parker Crosby
1865 – Barbara Errington
1881 – John Brown
1897 – Robert Brown

Turks Head
In 1804, there was a famous gun duel between a soldier and a gamekeeper who argued over who was the best shot. As a result, the weathervane of the Market Cross has two bullet holes in it. It is uncertain who won the argument...

Landlords:
1827 – James Peacock
1834 – Mary Peacock
1847 – John Barringham
1881 – William Cleminson
1897 – Jane Cleminson

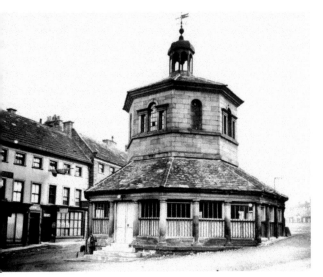

Above left: The Market Cross used as a target from the Turks Head. (Parkin Raine Collection)

Above right: The Golden Lion.

Golden Lion

The Golden Lion is said to be the oldest public house in the town and is thought to be built from stone taken from the castle. The date stone above the door reads 1697. As you 'descend' towards the back of the bar, you are actually walking into the castle's old moat. As with many market towns, different public houses would be used to sell grain, horses or butter and the Golden Lion was used to sell butter from the stables at the back. This changed when the Butter Market was moved to the lower floor of the Market Cross when built in 1747.

Landlords:
1834 – J. Heslop
1847 – John Errington
1854 – John Howson
1865 – R. Howson
1894 – Thomas Dobson

Raby Hotel

There used to be a bull-baiting ring attached to the front of the Raby Hotel before it was moved to Newgate. Bull baiting had been around for centuries and butchers were required to bait bulls before they were slaughtered as it was believed this made the meat more tender. It involved dogs being set on the bull, tied to a fixed ring.

A breed of bulldogs known as Lonsdales were named after a butcher who lived in Barnard Castle around 1780 and were very popular breed. Bull baiting was made

Horsemarket.

illegal in 1835, but people still continued to partake in the practice for numerous years after the ban.

In the 1990s the Raby Hotel became Folly's before reverting back to the Raby Hotel.

Landlords:

1855 – Peter Dent

1894 – George Burton

1906 – John Ward

1938 – Fred Woodams

The Bay Horse, or the Old 'Gentlemen's Club'

The Bay Horse closed in 1987 and was refurbished into accommodation, but the rear of the building became the wine bar.

Landlords:

1827 – George Bell

1847 – Robert Brotherton

1865 – William White

1897 – John Thompson

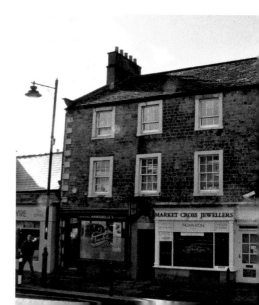

The old Bay Horse.

The Waterloo
Landlords:
1827 – Ben Sweeten (who was a veteran from the Battle of Waterloo)
1830 – George Pearson Dalston
1834 – Mary Hunt
1854 – George Pearson Dalston
1894 – James Dalston

The Board, Market Place
Landlords:
1847 – John Davidson and Thomas Bell

The Fleece, Market Place
Landlords:
1827 – Michael Woodhave

Goliaths Head, Horse Market
The Goliaths Head was located next to the Star Yard, where Greggs is located, and was renamed 'The Star' in the twentieth century – hence Star Yard. The Barnard Castle Hermit spent time living at the Goliaths Head between stints at the castle and Egglestone Abbey.

Landlords:
1823 – First mentioned
1827 – George Wilson
1865 – Robert Hind

Half-Moon and Seven Stars
Landlords:
1827 – John Dalkin
1862 – Thomas Hewson
1881 – Martin Stapley
1897 – John Littlefair

The Hart, Market Place
Only one mention, in 1682.

Hat & Feathers
The Hat & Feathers was first mentioned in 1827.

Landlords:
1834 – James Minikin

The Ox, Market Place
The Ox was first mentioned in 1827.

Landlords:
1834 – John Thwaites

The Queens Head, Market Place
First recorded in 1791 as having 'dancing bears and a side show'.

Landlords:
1827 – Francis Shields
1847 – Margaret and Hannah Shields
1865 – John Bell

Baliol Arms
Landlords:
1894–1897 – Thomas Bell & son

The Old Bull, Market Place
On 22 January 1773, John Wharton opened Wharton's Cock-fighting pit, where heavy betting used to take place.

Newgate

The Black Horse, No. 10 Newgate
First recorded as the Black Swan in 1611 but pre-1820 became the Black Horse. The pool room used to have paintings said to date from the 1700s.

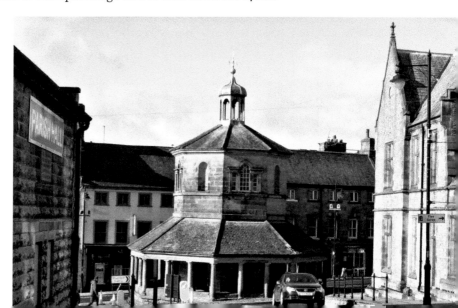

Newgate.

The Black Horse, Newgate.

Landlords:
1827 – James Wilkinson
1837 – Jane Wilkinson
1894 – Jane Harrison

The Old Black Horse, Newgate
Landlords:
1827–47 – Mary Richmond

The Dun Cow, Newgate
Landlords:
1834 – Thomas Brass
1847 – Ann Brass
1854 – Robert Hollier
1868 – Thomas Whorton

The Durham Ox, Newgate
Landlords:
1847 – Mary Atkinson

The Queens Head, Newgate
The Queens Head was eventually pulled down to make way for a 'Backhouses Bank' in 1898.

Landlords:
1897 – Robert Henry Dobson

The Three Tunns, Newgate
1827 – Joseph Nevison

The Three
Horse Shoes.

Galgate

The Three Horse Shoes
Landlords:
1827 – Mathew Hedley
1862 – Elizabeth Hedley
1897 – Margaret Hedley

Commercial Hotel
Landlords:
1854 – Mrs Todd
1855 – James Burt
1856 – Mrs Todd
1865 – William Hutchinson
1914 – John Patterson

Coach and Horses
Landlords:
1857 – Thomas Oliver
1865 – Thomas Oliver
1881 – Edward Hardgraves
1897 – Joanna Dawson

Cricketers Arms
In 1897, the Cricketers Arms was a barrel makers and brewers before becoming a public house in around 1920. It did not get its spirits licence until 16 February 1949, when it was known as The Cricketers Hotel. The premises could have been the location of the Joiners Arms. No. 48/50 Joiners Arms is mentioned in 1867.

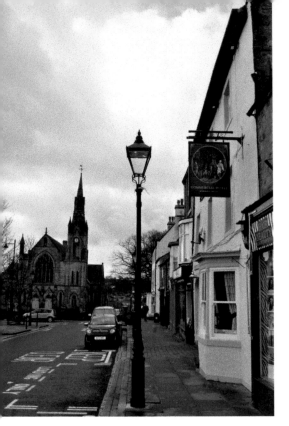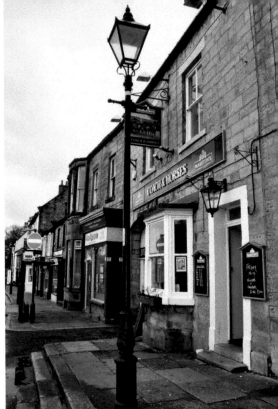

Above left: Commercial Hotel.

Above right: Coach and Horses.

Bowes Arms
No mention until mid-twentieth century.

The Cross Keys Inn/Old Cross Keys
Landlords:
1828 – Joseph Clifton

Horse & Hounds
The Horse & Hounds is mentioned as a Masonic meeting place but there are no further references.

The Streatlam Castle
First mentioned in 1827.

Landlords:
1834 – Joseph Dobinson

The Sun
Has only one mention, in 1769.

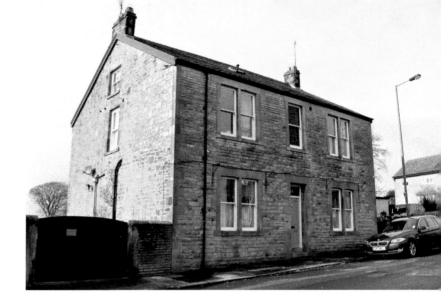

Old Montalbo Hotel.

Montalbo Hotel
The Montalbo was at first a temperance hotel and with irony became a public house in the twentieth century. It is now a private residence.

The Beaconsfield
A twentieth-century public house and recently an Italian restaurant.

Red Well Inn
The Red Well Inn was named after an iron oxide-rich spring nearby and is still a public house today.

Landlords:
1865 – John Wilkinson
1894 – John Wilkinson

The Beaconsfield.

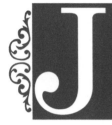

John Balliol, King of Scotland

John de Balliol II was an unlikely king of Scotland; not only was he born in Barnard Castle to an Anglo-Norman lord, but he was also the fourth son and not even considered likely to inherit the vast Balliol estates. He was expected to follow his education at a school in Durham and become part of the priesthood, which was considered a suitable career for a younger son of noble birth. Accounts of the time suggest he was a pious man and not suited to the challenges expected of a mighty lord, but soon his destiny would take a direction which would make him a significant figure from history.

His older brothers all died relatively young and without issue – Hugh *c.* 1271, Alan unknown and Alexander *c.* 1278 – leading to John II succeeding to the Balliol family estates in 1278. Born in 1249, he was thrust into a world he had not been trained for or a role he was never expected to command.

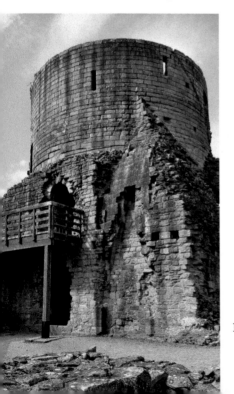

Barnard Castle, the likely birthplace of John Balliol.

The Balliol family had been in dispute with various bishops of Durham over lands in Sadberge, South Durham, where the bishops believed they were owed homage. John de Balliol Senior had raised the arguments just after his inheritance in 1229 and the quarrel intensified after 1255 when various violent outbreaks took place. But Balliol was serving as one of Henry III's English representatives in the Scottish government and this ongoing dispute did not serve the needs of the king, which finally led to Balliol's ultimate submission to Bishop Kirkham at Durham Cathedral in 1260. The understanding is that Balliol's penance was the foundation of Balliol College at Oxford University and another theory associated with this atonement called for Balliol's youngest son, John de Balliol II, to be educated at a Durham school. The Balliols could have provided for a private schoolmaster or chaplain to educate John, but clerical training was best done in a religious community.

His succession to the Balliol estates was not so simple and homage was demanded of John by both King Edward I and the Bishop of Durham. Though John's rights as heir were acknowledged, almost a year elapsed between Alexander's death and John's succession. During this time, the Balliol lands in Northumberland were taken into royal custody, and a chronicler recorded that John himself was also in royal custody at around this time. The reasons for his altercation with Edward I are not clear. Some have blamed John's marriage to Isabel, second daughter of John de Warenne, Earl of Surrey, but this is believed to have occurred later in February 1281. John seems to have spent a great deal of his time on his Picard estates between 1283 and 1285, but the next few years would see major changes to his situation.

In 1286, King Alexander III of Scotland died, leaving a succession crisis where his only heir was a young granddaughter called Margaret of Norway. When his mother, Devorgilla, died in early 1290, Balliol gained a further inheritance in both England and Scotland, which made Balliol a potential successor to the Scottish throne. Antony Bek, Bishop of Durham, acted on behalf of the Scots and for Edward to negotiate her marriage with the Prince of Wales, but tragedy was to strike when in 1290 the young Margaret died in a violent storm when sailing from Norway to Leith. The poor girl was only seven years old.

Edward was a wily old king, and by common consent a court was set up by King Edward I of England to determine the Scottish succession, the proceedings of which later became known as the 'Great Cause'. Of course, this would also allow Edward to influence the proceedings and gain some control over the final choice. The meeting took place at Norham Castle in June 1291, an extremely imposing fortress on the Scottish border overlooking the River Tweed, and the attending Bishop Bek was recorded as looking the part of strong negotiator, with the churchman wearing a sword and adorned with clothes covered with jewels. After an adjournment, on 2 June Edward first demanded acceptance of his lordship. Having evidently mistaken the day, Balliol arrived on the following day, and a notary was careful to record John's personal acknowledgement of Edward's lordship and jurisdiction. The argument and discussion took place over more than a year with records of the closing stages

of the proceedings being held in October–November 1292. The legal argument saw the seniority of Balliol over Brus since Balliol's maternal grandmother was an eldest daughter being adjudged to give him a stronger right to the kingship over his mother's cousin, Robert (V) de Brus, son of their grandmother Margaret's second sister, Isabel. The court's award of the kingdom in favour of Balliol was confirmed by Edward I, who finally awarded that kingdom to him on 17 November 1292.

The early part of John's reign seems to have gone well administratively and his authority was clear during the parliamentary sessions of 1293 to 1294, but politically he was to prove very weak in the face of pressure. Initially he defied Edward, but eventually under threat, he renewed his submission and homage to the English king. This revealed his inability to stand up for his rights when confronted by the domineering English king. Further friction came when John and twenty-six of his magnates defied Edward I's summons of June 1294, for overseas military service against the king of France. Indeed, later in 1295, a parliament in Stirling in early July appointed four Scots commissioners to negotiate a French treaty. The treaty drawn up in the October was endorsed by the Scottish king and parliament on 23 February 1296 and set out the terms of a military alliance between the two kingdoms. To enflame Edward further it made way for the marriage of John's elder son, Edward, to King Philippe of France's niece.

Conflict began with England at the end of March 1296 after a series of impossible demands were made by Edward as a pretext for war, and the first and last decisive battle was fought on 27 April 1296 at Dunbar. It was a clear victory for the battle-hardened English and the capable command of King John's father-in-law, John de Warenne, Earl of Surrey. Balliol escaped but in late June sent messages of peace to Edward, who was established at Perth. It was Antony Bek, Edward's powerful bishop in the north, who demanded 'John to surrender the kingdom, formally break the seal, and submit himself unconditionally to the king of England's will'. The official surrender was an embarrassing affair where Balliol confessed his rebellion and renounced the French treaty. Then at Brechin Castle on 10 July he resigned his kingdom and royal dignity. Some records also say he was taken to Montrose Castle, paraded before the people and the royal symbol removed from his surcoat or giving rise to his undying nickname of Toom Tabard, meaning 'empty surcoat'.

He was then escorted from Montrose to Canterbury and detained at the Tower of London, followed by Hertford, where he was allowed hunting privileges, until August 1297. Then returned to the Tower until July 1299, though it is recorded he spent time in accommodation of the Bishop of Durham somewhere outside London and, in the presence of the bishop, denounced his former subjects, alleging that they had tried to poison him. This was perhaps an attempt to claim he was coerced into his actions, but his intentions remain ambiguous.

In June 1299, Edward accepted French and papal demands for John's transfer into papal custody as part of the terms of an Anglo-French truce. He was transported over to Wissant-sur-Mer, and then transferred to the castle of Gevrey-Chambertin.

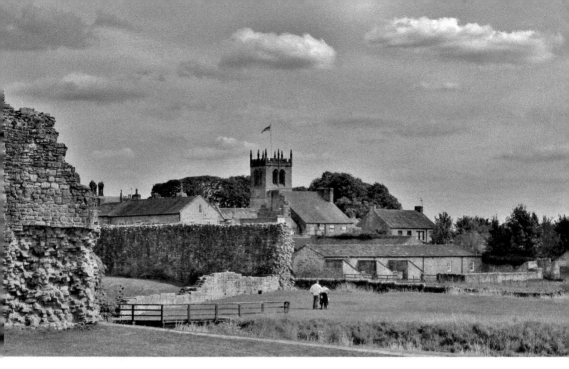

The castle bailey.

Rumours reached England that the king of France had moved Balliol to his castle of Bailleul in Picardy and Philippe intended to send John de Balliol back to Scotland with support. However, a defeat at the hands of the Flemings at Courtrai in Flanders in July 1302 dashed French hopes of a restoration of the Scottish king. A further Anglo-French truce in May 1303 enabled Edward to concentrate his efforts against Scotland, where by 1304 he appeared to have secured almost total military and political domination.

Edward I died on his way to another campaign in Scotland in 1307, but John still paid homage to his successor Edward II. Under this new king, who was not the dominating force of his father, there was a Scottish resurgence and John lived long enough to hear of the Battle of Bannockburn in June 1314. John Balliol, the king of Scotland, born in Barnard Castle, died at the end of 1314 and is thought to be buried in the church of St Waast, at Bailleul in France.

Below left: Oriel window, Barnard Castle.

Below right: View from the oriel window to the River Tees.

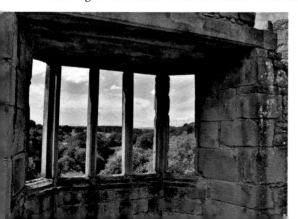

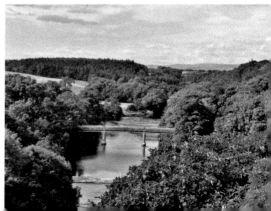

Kellett Woodland Murder

A most unfortunate incident happened on the night of 12 February 1870, ending in the death of a twenty-one-year-old man called Thomas Bainbridge. John Kellett, who lived in Woodland, was Thomas's father-in-law and during an altercation had shot and killed the young man. It was reported that both pitmen were drinking in Raine's Inn at Woodland and though it was known they did not get on very well, they did not seem angry as they left, Kellett first and Bainbridge after. It is known that Thomas's wife, Hannah, and two young children were staying at her father's house for health reasons. On Saturday night her father returned home around twelve o'clock and as soon as he came in, she locked the door. He took off his coat and waistcoat, to sit down in the armchair next to the fire, when Bainbridge came to the door and asked to be let in. She could hear that he was drunk, and told him to go away and return when he was sober, to which he shouted "You old b—, open the door, or I'll smash it in.' He bashed at the door again and as she was unlocking the door, he kicked the door in and walked into the room. Kellett got up out of his chair and grabbed his gun saying he would shift him, when Bainbridge seized hold of the gun at one end, and his wife also grabbed the middle. In the tussle they all fell down and got up to struggle for possession of the gun. Bainbridge then dragged Kellet outside, both still holding the weapon. There were a couple of steps to the house, and they fell over them onto the ground. It was at this point that the gun went off.

The gunshot attracted the attention of two men and the publican, Raine, who saw Kellett with the gun, disarmed him and carried Bainbridge to the house in great agony. Dr John Mitchell, from Barnard Castle, was sent for and arrived at the cottage just after 3 a.m. The bullet had entered between the eighth and ninth ribs, taking a downward course; there was around a yard of intestines protruding and part shot away. He bandaged the wound, alleviated the suffering and after 8 a.m. left as the wound was considered to be fatal. He died at around 1.30 p.m. on the Sunday afternoon.

PC William Hann was stationed at Lynesack, and had arrived at the scene to find Bainbridge lying on the floor in the middle of the room of Kellett's house. Kellett at the time was lying asleep on the longsettle (like a sofa bed) and slept until 3 o'clock.

As soon as he awoke, he was taken to Staindrop police cells to be locked up, but throughout the prisoner stated he had the right to defend his household. The officer had been told Bainbridge had burst the door open, but on examining the fastenings, he found both the lock and staple intact.

On the Wednesday, John Kellett was taken before the magistrates at Barnard Castle, to be formally charged with killing and slaying Thomas Bainbridge, at Woodland, in the parish of Cockfield, before a packed court. The magistrates were W. J. S. Morritt Esq. (chairman), Colonel Maude, and Morley Headlam Esq. After the evidence was given and the witness accounts listened to, the magistrates retired, and after a short absence, the chairman, addressing the prisoner, said they had given the case their utmost attention. It was seldom they had so painful a duty as that to perform, but they were unable to come to any other conclusion, and he would therefore be sent to prison for 'wilful murder'. The prisoner was removed and was conveyed to Durham Gaol. He appeared before the Durham Assizes on 1 March, where he was found guilty of the lesser charge of manslaughter and sentenced to ten years in prison with hard labour.

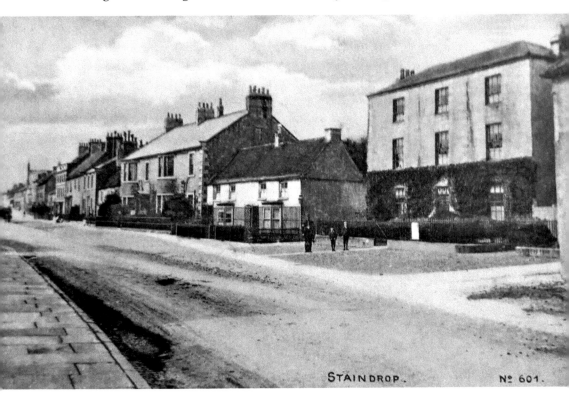

Old postcard of Staindrop, where Kellett was initially locked up.

London Lead Company

One of the most significant influences on the landscape and human geography of Upper Teesdale is the mineral mines (mainly lead but other minerals too), thought to be Roman in origin, but exploited during the medieval period, Elizabethan period and later in the eighteenth and nineteenth centuries. There is a route called the Maiden Way from Kirkby Thore on the A66, crossing the high ground to Alston where the fort named Whitley Castle was built, and believed to have been used to oversee lead and silver mining in the region. The top road from Barnard Castle to Eggleston may have been a connecting road from the mines of Teesdale back to Dere Street.

Many of the mines in Upper Teesdale belonged to Lord Barnard until the London Lead Company took on the first lease at Newbiggin in 1753, and this was followed eighteen years later by more mines and a smelting mill at Eggleston. Most of the workforce was local but in 1758, thirteen Derbyshire families moved to Teesdale to work in the Langdon Beck mine. The working conditions for these men and their families were very poor and too often men died young. This left families without a bread winner, and so they would become destitute and at the mercy of the poor law.

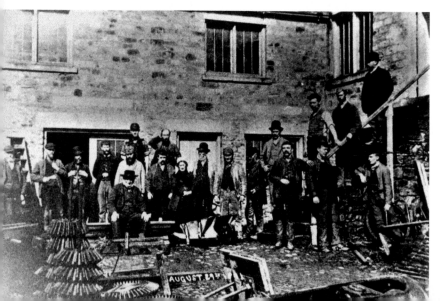

Old photo of London Lead Company workers. (Parkin Raine Collection)

The London Lead Company established its northern headquarters at Middleton-in-Teesdale in 1815, when they built the impressive Middleton House. The village became a company town as the population grew and in 1824 the company built new housing to accommodate them. New Town, Ten Row (now River Terrace) and Masterman Place are all originally company houses and as a Quaker company the London Lead Company also provided a workers' library for their education. Employees were expected to be of good character, hard-working and sober. They were provided with gardens and space for chickens or livestock. The company also supported cooperatives, brass bands and sporting activities, and a doctor was also provided. However, all too soon this began to disintegrate as the mines started to be worked out.

By the 1890s the mines were becoming uneconomical; foreign imports grew and other minerals like zinc were mined. As the company shrunk operations, some families moved to where the work was – for example, the Durham coalfields – while others returned to farming and quarrying. The London Lead Company ceased operations in Teesdale in 1905, and so ended a 150-year association with the area.

Below left: Entrance arch to Masterman Place.

Below right: Middleton-in-Teesdale water fountain *c.* 1877 to commemorate R. W. Bainbridge of Middleton House, agent of the London Lead Company.

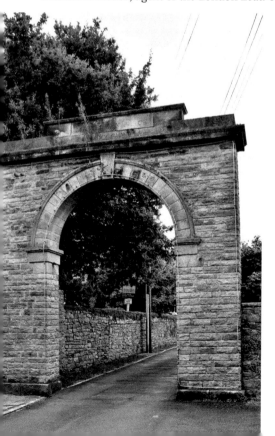
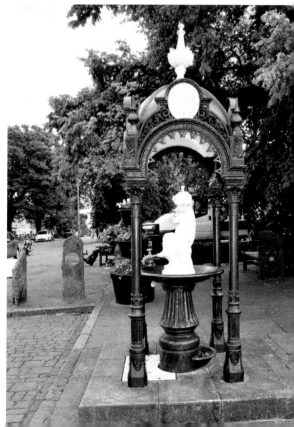

Museum – The Bowes

Though the building appears to be a French chateau, it is a purpose-built museum to house the collection of John and Josephine Bowes. John Bowes was born into the wealthy coal-mining Bowes family, but because his parents were unmarried at the time of his birth, he did not inherit the full title of his father John Lyon-Bowes, 10th Earl of Strathmore and Kinghorne. After legal challenges, he inherited the English estates, but the Scottish estates went to his uncle, who became the 11th Earl.

John spent a lot of his time in Paris, and it was while there that he met Josephine Benoîte Coffin-Chevalier, the daughter of a clockmaker. She was an actress, comedienne and singer under the stage name Mlle Delorme in the Théâtre des Variétés at the time when John Bowes purchased and managed the theatre. They both had a love of the arts and began a relationship soon after they met in 1847 and made their home in the Château du Barry in Louveciennes near Paris. They were married in 1852 and she retired from the stage to concentrate on her artistic pursuits and collecting.

Their collection was at first to be housed in a museum in Cologne in France, but due to the impending war with Prussia, John decided to build their museum in Barnard Castle and stored the vast collection at Streatlam Castle. In 1868, John Bowes purchased the title of Countess of Montalbo for his wife, from the small country of San Marino. This was done to elevate her status in society and is subsequently the reason streets and buildings in Barnard Castle carry the name.

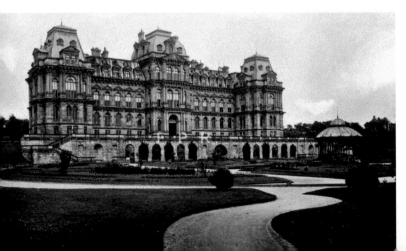

Bowes Museum.
(Parkin Raine
Collection)

Work began on the Bowes Museum in 1869, and was estimated to cost around £38,000 to build, a vast sum for the time, and rose to around £100,000 at completion. A French architect called Jules Pellechet designed the museum and a local contractor, Joseph Kyle, was employed to carry out the construction. When Josephine laid the foundation stone of the museum on 27 November 1869, she was apparently too ill to actually lay the foundation stone and could only touch it with a trowel. Unfortunately, in 1874, Josephine died of lung disease at the age of forty-eight in Paris and is reported to have spent her last days ensuring items for the museum collection were sent to Teesdale. She was interred at their Gibside estate in the Derwent Valley of North Durham and Bowes arranged for a bouquet of flowers to be placed on her grave daily.

In 1877, Bowes married another French lady, Alphonsine Maria St Amand, but the marriage was not a happy one and ended in separation in May 1884. During this time the museum build continued, but just over a year after the separation, John Bowes died. He too was buried next to Josephine at Gibside. Despite their deaths the project continued under the direction of trustees and was finally opened to the public on 10 June 1892, attracting nearly 63,000 visitors in its first year.

A half-built chapel, planned by John Bowes for the eastern side of the museum for his beloved Josephine, was halted by the museum trustees, and then pulled down. The materials were used to build the Roman Catholic Church on the corner of Birch Road and Newgate in the 1920s. John and Josephine were exhumed from Gibside and reburied in the grounds of the church very close to their precious museum. There is a story that Josephine walks the museum and you can catch a smell of her rich French perfume or sometimes she plays with its visitors.

The museum and its collection were taken over by Durham County Council in 1956. The museum was often visited by the late Queen Mother, who was descended from the Bowes-Lyon family, and it is safe to say the people of Teesdale also adore the French chateau built in a South Durham dale.

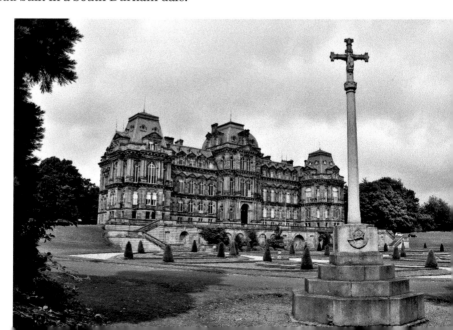

Bowes
Museum.

National School, Demesnes

The first National School was founded in Barnard Castle in 1814. The realisation of the idea of a school to an actual building was very quick, from being first discussed in 1813 to its completion in 1814. Though not a grand building, it stood on the south-east corner of St Mary's churchyard and housed around 150 pupils. The head teacher was the curate of St Mary's Church and received £1 a week in payment for his services. Founded on the Anglican principle, the National School Society was founded in 1811, so the Barnard Castle one is quite early in its inception.

Barnard Castle National School attendances were often poor, possibly due to the poorer children having to work to earn extra money for their families. It was recorded in July 1832 that more girls were absent from school than attended. Attendance was severely reduced during the 1847–49 cholera outbreak due to both the actual illness and the fear contracting it. In 1883, three orphans were dismissed from the school, as they had been playing truant and were sent to the Wesleyan Day School at the bottom of the Demesnes.

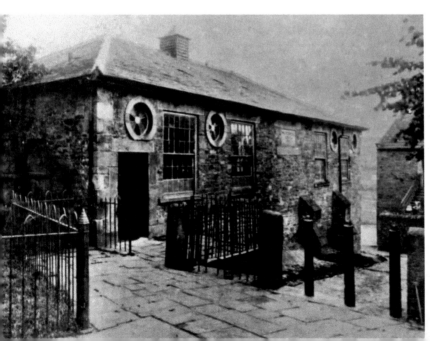

National School building.

The girls were taught needlework – the school logbook records calico was ordered by the yard and in batches of fifty – and not all the girls were well behaved: 'The girls have behaved well this week on the whole, with the exception of a few girls who received no marks for talking'. After a quarter of a century the girls were moved to another girls' school on the south-west corner of the churchyard, but the boys continued in the first National School, being taught Maths, English and other academic subjects.

The first National School was demolished to make way for a new one that would accommodate both boys and girls. Mr W. Watson, who lived at Thorngate House, gave most of the £5,000 required to build the new school. The Watson family later moved to Spring Lodge on Newgate. The architect and builder of the new school was to be Mr Joseph Kyle, who was also the builder of the North Eastern County School and the Bowes Museum.

As the school was built on quite a severe slope, it was Mr Kyle who came up with the idea to make it level and set the rear of the building out as normal but added large stone lintels over stone arches for the classrooms facing the river. These arches were over the playground at the front elevation overlooking the demesnes and river. To add grandeur the new school included wide pointed gables that seemed to reach for the sky. Mr Joseph Kyle was again creating a fine building for the town as he had before and would again. He was praised for his well-lit and ventilated school. He had also added wooden partition walls that could be pulled back and forth to change the size of each classroom and make larger areas for physical activities. Ventilators were added to the roof to circulate good air throughout – all to the specifications of the National Schools Society standard for schools at that time. This second National School was completed in 1882 and as a tribute to the first National School, the old date stone was added to the north exterior wall facing onto St Mary's churchyard bearing the date 1814.

At first the girls and boys at the new National School were taught separately and attendance improved considerably, and if attaining good attendance weeks, the whole school was given a day off. Some special days were also celebrated at the school like Empire Day, Monarchs Day and a Tradesman's Day when children would go with their parents.

By 1913 the school was teaching the boys more manual work and on the upper Demesnes the school had a garden. It was always well maintained unless the cattle and sheep from the Demesnes pasture got into it and ate the vegetables.

A major change came in 1915 during the First World War when like many buildings in the area the National School became accommodation for drafted soldiers brought into the area. When things returned to normal in 1918, the school started to play matches between other schools in the area. By 1930 the garden at the school was no longer part of the curriculum because the school changed from a boys and girls school to a junior and infants school. On Wednesday afternoons the boys would play football or cricket on the lower Demesnes and the girls did needlework.

One major evening for the town was in July 1933 when the whole school was let out early to witness the felling of the Thorngate factory chimney, a factory specialising in protective clothing for the Admiralty and steel industry. There are old photographs showing the great view the children must have had, as the school overlooked the scene of destruction.

After the Second World War the National School system belonged in the past and the school became the Barnard Castle Church of England School. As the number of pupils began to rise some additional temporary classrooms were added to the west of the school; however it became clear that the school was becoming outdated and by 1977 it was closed. The teachers and pupils were transferred to the new school on Green Lane, which was a much more modern building suitable for modern teaching.

The National School lay dormant and began to become ruinous over the next twenty years or so. The Teesdale district council and others decided something had to be done and it was thought to demolish the building to turn it into luxury flats. After five years of planning applications, a war of words and much arguing, in 1992 work began on the new flats and housing that would stand on the site of the temporary school huts, and today we still have the fine building.

HRH the Queen Mother opened the first luxury flats in late 1992 and there is a blue plaque to commemorate the event. I often wonder what Mr Kyle would have made of the new flats built into his school; I'm certain he would have been pleased that the school was saved.

Barnard Castle School, originally North Eastern County School.

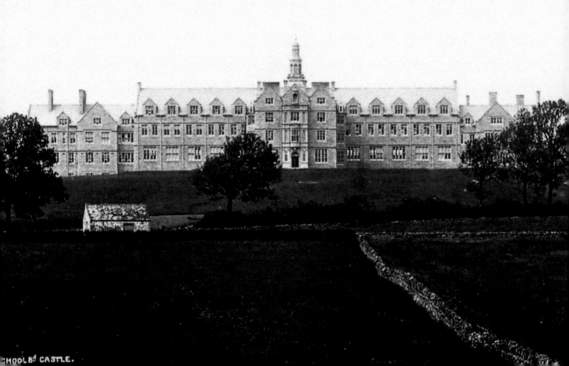

CHOOL B? CASTLE.

O

Objectors – Conscientious

During the First World War there were quite a number of men who were Conscientious Objectors: men who had asked for exemption from military service because it was against their beliefs. Many were Methodists, Quakers and Jehovah's Witnesses, and even some Socialists. Where some men from these faiths would become medics or orderlies during the fighting, some refused to undertake any work involving the war effort. The castle at Richmond has an exhibition of where some of these men were held in cells and became known as the 'Richmond Sixteen'. They were sent to France in May 1916 and were put on trial for refusing to obey orders. They were sentenced to death, but the sentence was eventually commuted to ten years' hard labour. Teesdale also had a few objectors, one of which lived in the Hude at Middleton-in-Teesdale. Another was from Newbiggin and was court-martialled at Sunderland in 1918. He was given two years' hard labour, commuted to one year at a tribunal at Wormwood Scrubs, but was still there until at least May 1919.

Herbert Muschamp Lingford, who was a baking powder manufacturer, lived in Cotherstone. He was Quaker, and from 1915 he was part of the Friends' War Victims Relief Service. In August 1916 he was involved in the Friends' Ambulance Unit and sailed for Salonica, not returning until February 1919. He would have probably known a valuer and auctioneer from Galgate in Barnard Castle who was also part of the Ambulance Unit. It was 1916 when conscription was introduced and around 20,000 men countrywide registered as Conscientious Objectors during the following two years. Some of these men were branded a 'conchie' and were portrayed as the enemy, and described as traitors or cowards, as well as being vilified by the local populous.

Richmond Castle has an exhibition relating to the Conscientious Objectors.

Ponies – Teesdale or Dales Ponies at War

The Dales pony is a native mountain and moorland breed, known for its hardiness, stamina and strength, often linked to the history of lead mining in the Dales area of England, from Derbyshire to the Scottish Borders. It was a working pony which was used throughout Teesdale in the lead mining and agriculture industries for hundreds of years. It was these skills and traits which made these ponies perfect for another more difficult task.

In 1914 when the call to arms came as Europe was plunged into the First World War, men from all over the country answered, all keen to fight for King and Country, but the British Army found itself with a problem. Totally unprepared for this industrial war, there was a lack of horses and strong ponies for the cavalry, gun pulling and supply of ammunition or stores. Teams were sent out across the country to round up and bring back ponies, horses and even donkeys to be shipped out to the fronts in Europe, Africa and the Middle East. A great number of ponies from Teesdale were conscripted and shipped out to the war.

Those that survived the journey were thrust straight into the action, where some went mad with the sound of the guns – just as many of the men did. Some men formed close bonds with their animals and may have had the briefest of training themselves, with some having a few months on a wooden rocking horse at a training camp in York, then off to the front to face the barbed wire and machine-gun fire. The war was a bleak existence for the horses and ponies and when food was scarce, they would be seen gnawing on the wooden carts. The daily ration for a horse, pony and mule was 20 lbs of grain a day and this was only three quarters of what a horse would be fed in Britain. When grain was in short supply, the army substituted the feed with sawdust.

Though the numbers are not known exactly, in some battles more horses were lost than men and of the millions sent overseas, only in the region of 62,000 made it home. The bonds formed between the men and their horses grew so strong that by the end of the war in 1918, men would pay to save them. The alternative in a ruined Europe, gripped by an influenza outbreak and horses in such bad condition, was for them to be given to Belgian butchers to provide meat for starving people. Many animals (horses, dogs, pigeons) who had served their masters throughout the horror of war found themselves paying the ultimate price for their service.

Comet is quite old in this photograph – around twenty-four years of age. He is being driven by Mr Arthur Watson. (Parkin Raine Collection)

One of the most famous Dales ponies was the Teesdale Comet bred by a Mr G. Gibson of Middleton-in-Teesdale. In 1902, he was described in the *Teesdale Mercury* when appearing at show in Barnard Castle:

Teesdale Comet, owned and exhibited by Mr Leonard Temple of Middleton-in-Teesdale, had quite a little crowd of admirers. Without doubt this horse is a true specimen of a dales pony, of the improved breed, and which class of animals are now so much in demand. He is a fine dappled grey, with plenty of bone, fine action and beautiful feather. Judges of horse flesh and farmers were captivated with the all-round excelling moving properties of the local Comet.

Quakers, Catholics and Methodists

Teesdale has had a long association with various religious doctrine and for a time was a centre of underground Catholicism in the north of England, the home of meeting places for Quakers and greatly influenced by Methodism.

Friends Meeting House, Cotherstone. (Courtesy of Brenda Thwaites)

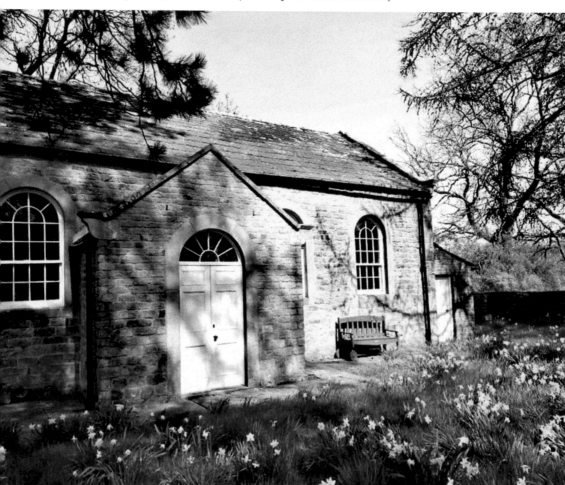

Quakers

George Fox (1624–91), the founder of the 'Quakers', grew up in Leicestershire during the turbulent events of the English Civil War and was obviously a deep-thinking child. When he was only twelve years old, he was apprenticed to a local tradesman, but he left home in 1643 to seek 'the truth'. He would listen and learn from different preachers and others, to develop his own ideas and beliefs and came to believe that everyone had the 'light' of God within themselves. Therefore, priests were not needed to relay God's message and there was no need for a church or to pay tithes to support them. This opinion was not popular with the Church of England. Those who agreed with Fox became known as 'Friends of Truth'.

These ideas came to the attention of the authorities and Fox was imprisoned for the first time in Nottingham in 1649. Apparently, the term 'Quaker' came from a remark by the judge in Fox's second trial, in Derby, in 1650, when he said they quaked before God.

The origins of Quakerism in the north come from the early years of the faith when in 1650–51 George Fox travelled the length and breadth of the North and East Ridings of Yorkshire, until by the end of 1653, the main areas of Quaker convincement were Westmorland, Cumberland, North Lancashire, Durham and Yorkshire.

James Nayler was the first to take up the mission in the north and in the summer of 1653, he held a meeting at the home of Ambrose Appleby of Startforth. The rise of this new religion was slow and there were only five Friends in the parish by 1669 with meetings being held in the dales of Lune, Balder and Greta. One meeting was held in 1666 at the home of Thomas Wrightson at North Gill in between the moors of Lartington and Cotherstone, but they were arrested and sent to the House of Correction at Richmond. They included members of the Appleby and Raine families, as well as John Bowron of Cotherstone, who was one of the 'First Publishers of Truth' to come from the area.

Further meetings occurred in Lartington in 1675, with meeting places registered there and in Cotherstone in 1689. There was an Ann Kipling's house in Bowes and James Raine's in Stoneykeld registered in 1694. A Meeting House and a burial ground were acquired in the village of Lartington in 1701 and when this was sold in 1796, the proceeds were used to purchase a new site in Cotherstone. The Cotherstone Meeting House was built in 1796 and opened the following year. This Meeting House is still in use today and is located just out of the village on Demesnes Lane. The building is now listed and is of a simple construction with a porch added c. 1837.

Other meetings were held in Staindrop, called the Shakerton Monthly Meeting, but in 1675 it was renamed Raby Monthly Meeting. A new Meeting House was built in 1771 in Staindrop to accommodate the Monthly Meeting. In 1820 the Monthly Meeting was discontinued, and its remaining meetings transferred to the newly formed Darlington Monthly Meeting.

One of the greatest influences on the dale by the Quakers was seen at Middleton-in-Teesdale, a small market town, until the London (or Quaker) Lead Company decided

Hole in the Wall, Barnard Castle.

to relocate its northern headquarters there from Blanchland in 1815. For the next 100 years the impact of this company was significant with many new buildings erected during the period and new workers' homes built to house the workers. The Quakers were benevolent bosses and cared for their hard-working employees, building solid and functional dwellings as well as schools and welfare facilities. By 1857 it is said 90 per cent of the population were involved in the lead-mining industry, though they never built a Quaker Meeting House and by the time of the First World War they had closed the business down.

Methodists

The impact of Methodism on the dale was incredibly significant from the mid-1700s due to a son of the Revd Samuel Wesley, Anglican rector of Epworth in Lincolnshire, and his wife, Susanna (née Annesley). John Wesley was educated at the Charterhouse School in London and at Oxford University before he was ordained as an Anglican deacon in 1725, and priest in 1728 at Christ Church Cathedral. He became a tutor and Fellow of Lincoln College and along with other friends became members of a 'Holy Club' nicknamed 'Methodist' due to its views of disciplined piety.

John Wesley spent the next few years in spiritual contemplation and along with his younger brother was involved in a calamitous period of missionary work in America. The journey to the colonies was rough and he questioned his beliefs, even falling

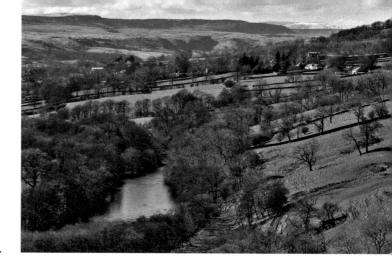

Teesdale was heavily influenced by Methodism.

in love but withdrawing from his marriage plans, which caused more uncertainty. However, in 1738, John had a spiritual experience that convinced him of the truth of his salvation through faith in Jesus Christ and he began to preach that this salvation was available to everyone.

A fellow Holy Club turned Methodist preacher, George Whitefield, invited John to preach in Bristol where John built the very first Methodist building. John Wesley set about travelling the country to preach the gospel and it is estimated he completed 250,000 miles in fifty years.

Religious persecution at this time meant the first meetings of Wesleyan Methodists in Barnard Castle were held in secret, and the first recorded are as early as 1747 at the Galgate home of Grace Dunn. She would notify people about the meetings by hanging a handkerchief out of the window. During these meetings the members would read from the Bible, sing hymns and pray.

John Wesley first visited Barnard Castle in May 1752 and set up outside the home of Joseph Gargett, which was later demolished to build the Witham Hall. Methodist Wesleyan worship was established at the 'Hole in the Wall Meeting House' (1750–65) until land was procured adjoining the Demesnes. The Broadgates Chapel was opened by John Wesley in 1764. This chapel was significantly expanded with the construction of a west wing and by 1810 a Sunday school was opened. The Broadgates Chapel was replaced in 1822–23 by the Wesleyan Chapel behind No. 40 The Bank, which is now demolished. There was also a Primitive Methodist Church on Newgate, preceded by a small building in what is still known as Ranters' Yard.

Methodism proved very popular with the Upper Teesdale lead miners and in 1759 they purchased land and built a chapel at Newbiggin. This chapel is thought to be the oldest Methodist chapel in the world in continuous use and still has a pulpit from which John Wesley preached during his northern circuit in 1761. The building is now a museum. In later years most of the villages and hamlets in Teesdale built a Methodist chapel.

As the movement grew in Barnard Castle there was a call for a larger building and the land at the bottom of Galgate was given over by the Duke of Cleveland. The church was designed by chapel architects Morley and Woodhouse, of Bradford and

Above left: Restored chapel in Romaldkirk.

Above right: The spire of the Methodist church in Barnard Castle.

Bolton, and the construction of the church was given to Barnard Castle builder Joseph Kyle. The joinery work was to be carried out by Mr Robinson of Lartington, and the plumbing and glazing by Mr C. Raine of Barnard Castle. All for a total cost of around £3,500, of which £2,450 was raised through subscription. The foundation stone was laid on Friday 20 January 1893 by Lord Barnard, who was presented with an inscribed silver trowel by Gibson Kyle on behalf of the construction team. The Holy Trinity Methodist Church was opened on 30 March 1894 by various senior Wesleyans who all gave sermons.

Catholics

Prior to Henry VIII the country was Catholic and supreme religious power was held by the Pope. Henry's desire for a male child led to a break from Rome and resulted in the Dissolution of the Monasteries. Lartington seems to have been a centre for Catholic sentiment during this period and is recorded in the 'Rolls of Henry V' as having a licence granted to Henry and Elizabeth Headlam to found a chantry in the chapel of St Mary at Lartington. The document dated 25 May 1414 also refers to a John

de Laton, the parson of the church of Rumbaldkyrk; John Eppelby the elder, chaplain; Thomas Soureale, chaplain; Robert Jakson of Castro Bernard, chaplain; and Henry Hedlam and Elizabeth, his wife. It was dedicated to Our Lady, and in 1546 was valued at £5 6s 8d per annum. The building was recorded as still standing in the year 1620, but there is not a trace remaining today. Also, during the Pilgrimage of Grace, the rising against the Dissolution of the Monasteries in 1536, a William Tristram, chantry priest of Lartington, donned his armour and rode to the countryside to rally support for the cause. He was accused of being one of the busiest priests in the cause of insurrection and was rebuked for being overzealous in bearing arms, raising money and encouraging parishioners to fight.

The country reverted to Catholicism under Mary I but returned to Protestantism under Elizabeth I from 1558. Her long reign was fraught with religious uncertainty as Pope Pius V sought to depose Queen Elizabeth by the issue of a papal bull which declared her a heretic and relieved her subjects of any allegiance to her. This led to suspicion and uprisings against her, including the 'Rising of the North' in which Barnard Castle played a major part. The Recusancy Acts made it a legal obligation to worship in the Anglican faith and later assassination plots in which Catholics were prime movers fuelled anti-Catholicism in England. During the reign of James I, the Gunpowder Plot was a Catholic plan to return the country to the 'old faith', and the brief reign of the Catholic James II raised the issue again until the Glorious Revolution of 1688 overthrew him in favour of the Protestant pairing of William of Orange and Mary II. The 1701 Act of Settlement stated that Catholics would be excluded from the succession to the throne and various Jacobite risings during the eighteenth century by the Catholic Stewarts only added to the paranoia of the time.

In this environment of persecution and suspicion, the Catholics of Barnard Castle and Upper Teesdale would cross the River Tees or head down the dale to attend Mass in Lartington Hall, which was in the parish of Romaldkirk in the North Riding of Yorkshire. One of the oldest missions, the registers date from 1700, in which year a chapel was built alongside the house by Thomas Maire, the squire. Lancelot Pickering was chaplain there for fifty years (1713–63) and one Edward Kitchen was there for over twenty years (1772–93) but apparently he died at Lartington, insane.

At this time a large number of Catholics lived in the Wapentake of Gilling West, who attended Mass at Wycliffe Hall, the home of the Tunstall family, south of the Tees below Whorlton. A domestic chapel was rebuilt here in 1748 and served a considerable number of worshipers until the middle of the nineteenth century. The congregation at Lartington consisted of some twenty-five Teesdale families at the beginning of the nineteenth century, many of whom lived in Barnard Castle. By 1829, the political climate had changed enough to allow Parliament to pass the Roman Catholic Relief Act 1829, giving Catholics almost equal civil rights, including the right to vote and to hold most public offices.

In 1847, by which time the Catholic population of the town was estimated at 200, Owen Longstaffe rented the Union Hall and adapted it for use as a chapel; he also

provided the stipend for a resident priest. Three years later he bought the property for £400 and gave it to the mission. Longstaffe, born in Lincoln and married to Lucy Ullathorne (aunt of the bishop), had been taken into partnership by his father-in-law, Francis, to manage 'the extensive flax tow and spinning wheels of Messrs. Ullathorne and Longstaff, established in 1798 and whose manufacture of shoe threads gives employment to between 400 and 500 hands' in Startforth and Barnard Castle. Longstaffe later set apart a room in the mill as a Catholic schoolroom.

As the eighteenth century turned into the nineteenth, the family name Maire of Lartington Hall changed through marriage to become Silvertop-Maire and then it was later Henry who changed his name to Witham when he married the heiress, Eliza Witham of Headlam. He also held estates at Hardwick, and through marriage, he also included the estate of Cliffe Hall, near Piercebridge. So, at the turn of the century, Witham possessed three Catholic estates, each having a long-standing chaplaincy. The problem for Henry was his love of gambling. At one point he had arranged a ball at the hall to celebrate the anticipated win of a fellow Catholic's horse called Doctor Syntax, which was sure to recover his fortunes. However, the horse lost, the dance was cancelled, and he absconded to Scotland to escape his creditors. Over the next few years he spent time on his other interest, fossils and geology, while his mother resolved his financial issues by the sale of the Hardwick estate, which went to the Earl of Darlington in 1819. Within a year, Darlington had cut enough timber to recoup his investment but soon recovered an abundance of coal to increase the value of the estate exponentially.

He returned from Scotland to take over the estate and was in fact greeted with a parade through Barnard Castle – the people must have been happy to see the return of this extravagant spender. The older Witham was a much more responsible individual and a benevolent man. He founded the Mechanics' Institute in Barnard Castle and he supported the Dispensary Society, which provided the poor with medicine. To his other passion he commissioned architect Ignatius Bonomi to build a museum at the hall to exhibit his geological specimens, and a library for 3,000 books, his paintings and his collection of fossils. The museum was completed in 1836, though the room is now called the Ballroom. His specimens are now part of the Hancock Museum collection in Newcastle.

As he grew older, he stated that he would like the Mechanics' Institute to have a permanent home and in November 1844 when he died, it was decided that a building would be a fitting memorial to him. The local community felt a building to his memory and a home for Barnard Castle Mechanics' Institute and the Dispensary would be suitable. The funds were raised by public subscription. Apparently, the sum raised did not match the lavish plans for the building, but John Bowes made a significant personal contribution that enabled the project to go ahead in 1845. The building is now known as Witham Hall and stands in the centre of the town.

The estate passed to his eldest son, George, but he died three years later, and Lartington Hall came into the possession of the only surviving son, Thomas Edward

Witham, who was forty-one years old and a priest. He immediately applied to Rome for a dispensation to marry and maintain the line, but the request was refused. He relished the role of squire at Lartington Hall and became an indulgent man, known for keeping a good cellar, even though he had the village inn closed. The Right Reverend Monsignor Thomas Edward Witham continued to live in the hall until his death in 1897.

Catholic church, Barnard Castle, where John and Josephine Bowes are buried.

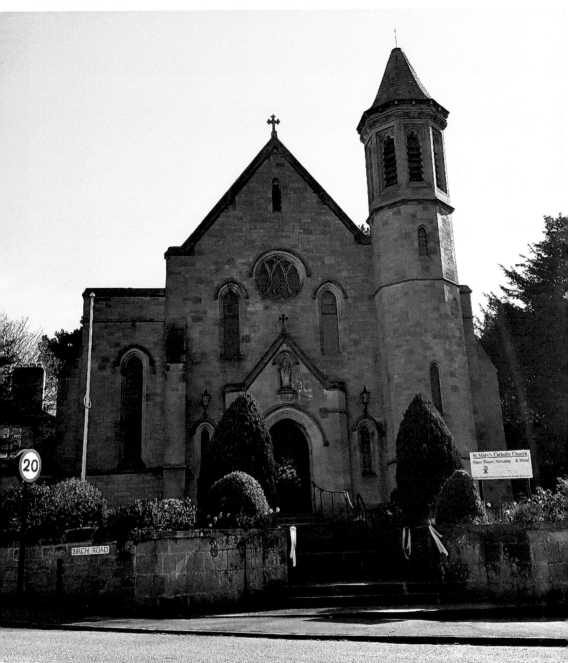

Richard Watson

Richard Watson was born on 16 March 1833 to William and Rebekah Watson of Ten Row in Newtown, Middleton-in-Teesdale. The Row houses were built in 1823–24 by the London Lead Company, who employed Richard's father, and housed twenty-five lead miners as well as two overseers. A Reading Room and a building to house the water supply were also built. William Watson worked in the grim conditions of Syke lead mine for very little money and died after many months of a lingering illness at the age of forty-seven. Richard Watson left school at the age of ten instead of twelve to help the family bring in a wage and keep a roof over their heads, and like his father he worked for the company, beginning as a washer boy earning sixpence a week. To increase his income he would also run errands for local shops. The young Richard Watson was encouraged into writing short stories and poetry by the Middleton rector, John Henry Brown (known locally as John Henry), and he was found to be a 'dab hand' at poetry, creating rhymes about his workmates in the mines.

At the age of twenty-four Richard met his long-suffering wife, Nancy Brumwell of Ettersgill. Nancy was twenty years old and on 24 September 1857 the pair were

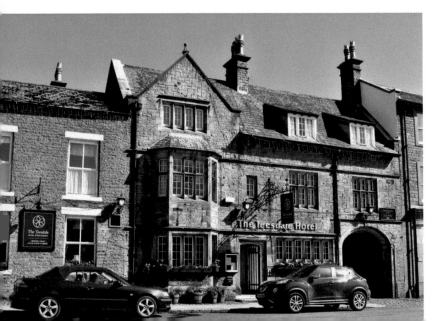

The Teesdale Hotel, Middleton-in-Teesdale.

married at a registry office in Barnard Castle. Afterwards they moved in with Richard's mother, who was by this time living in rented accommodation at Bridge Lane in Middleton-in-Teesdale. He raised a family while working at various lead mines around the town, but he was a dreamer, and was said to be not too fond of hard work; it was Nancy and their daughters who earned the extra pennies needed to survive. Nancy had 'a sharp tongue' and it is reported that she did not hold with Richard's writings and poetry, and would try to goad Richard into pushing for a good hard-working job in the mine.

However, Richard continued to dream and in 1862, he was first published in the *Teesdale Mercury*, with a poem about a conversation between the castle tower and the Auld County Bridge. His first volume of poems was published in the same year. Richard's friendship with the *Teesdale Mercury* newspaper editor and printers the Atkinson Brothers meant most of his poems would appear in the *Mercury* and his second book was published in 1884, entitled *Poems & Songs of Teesdale*.

The first public performance by the famous Bard of Teesdale was to mark the appointment of Octavius Wigram as the new London Lead Company governor in Middleton and meant the whole village was involved in the preparation for the function. All the publicans were told to prepare lunch for the London Lead Company's 1,300 employees, and local masons built ovens to keep the food hot. The meal was held on the rifle volunteers parade ground, with the clerks and foremen to act as waiters to each sitting of 600 men. The Mickleton band provided the music, and in front of the whole group, including the new governor, Richard Watson gave his first public performance of his poetry. He proved to be very popular and fairly soon job offers came flooding in, including one from a Mr Ralph Raine from the local chemist shop who requested a poetic advert for his business:

> If you want to drink your heart to cheer,
> to keep your craniums cool and clear,
> Forsake your whiskey, rum and beer, of ills Source,
> Raine's cordial noted far and near, is best of course.

As a youth Richard lost the sight of one eye after an accident at the mines, and at the age of fifty-four he entered into a partnership with two men named Scott. They mined Abarytes mine near Snaisgill, but one of the Scotts was also blind in one eye. Having these two men working in the same mine was never going to last long and soon the partnership was dissolved. By the 1890s the London Lead Company was in decline and it was getting harder for men to find work, especially for senior men like Richard Watson.

Then in March 1890 disaster struck the Watson family when their daughter Mary, who had always helped her father with his writing, died after a long illness. Her death greatly distressed Richard and he lost interest in writing. Mary was buried in Middleton churchyard and much sympathy was shown by the good people of

Middleton-in-Teesdale. Not long after her funeral, Richard was given a construction job helping to build Holwick Mansion. This grand building was being built as a shooting lodge for Cosmo Bonsor, MP and Director of the Bank of England, but while working on the mansion a large stone block fell and crushed Richard's foot. His foot had to be amputated, but when the injury developed gangrene, he was sent to Edinburgh Royal Infirmary for treatment. Unfortunately, he died on 2 October 1891 with his wife Nancy by his side.

Richard's writings gained more fame after his death and today they are considered to be a real insight into the world of nineteenth-century Teesdale. His words also enlighten us to the bitterness of his feelings towards the lead mines that ended his father's life prematurely:

> Large rubbish heaps along the hillside show,
> The vast extent of hollow earth below,
> Here toiled my father for his bairn's support,
> Till poverty and toil his days cut short.

Richard Watson was also a comedian and in an ode he wrote this for a man who once sold fish from a handcart in Middleton:

> Here lies the body of poor old Whit.
> He's dead and gone now to the Brimstone pit,
> The Devil his soul he did not wish,
> Because he stinks so much of fish!

Teesdale and beyond should be grateful to John Henry, the Rector of Middleton, for encouraging the young Richard Watson into continuing to write his poems.

Graveyard of St Mary's, where Richard Watson is buried.

S

Sanderson, Major

Major John Sanderson was an officer in Colonel Robert Lilburne's regiment of horse during the English Civil War and in 1648, between 11 January and 30 December, he compiled a diary with over 270 entries. The diary contained some well-known events, but also revealed details of patrols, where they were billeted and any small skirmishes.

Throughout the mid-seventeenth century the Civil War between the supporters of parliament and the supporters of the king raged throughout the country and though Teesdale was not the scene of any major conflict, the area was used as a stopping-off

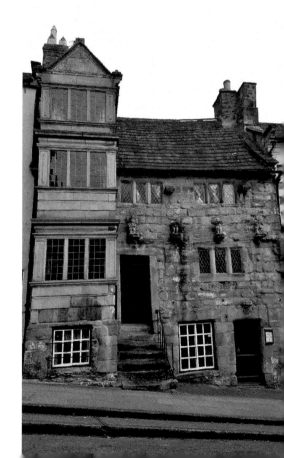

Blagraves.

point or conduit for strategic troop movements. In 1642, the Royalist Earl of Newcastle marched south into Yorkshire with a force of 8,000 and it was the Parliamentarian Captain Hotham who attempted to prevent the Royalists from crossing the River Tees at Piercebridge. He was entrenched on the high ground of the Cliffe estate. Initial successes drove back the Royalists but as the Earl of Newcastle pointed his heavy guns onto the opposite high ground at Carlbury, the Parliamentarians, outnumbered and under bombardment, withdrew.

The so-called Battle of Piercebridge could be described as more of a skirmish than a significant engagement. In 1644 as the Parliamentarian troops besieged the Royalist garrison at York, the Royalist troops of the Marquess of Newcastle moved south to defend it and travelled via Bishop Auckland, Barnard Castle and Piercebridge.

During the Second Civil War in 1648, when Charles I negotiated a secret treaty with the Scottish 'Engager' group and promised to impose Presbyterianism in England, there was a series of Royalist uprisings throughout the country and a poorly organised invasion from the Scots. Major Sanderson recorded in late February that he and his troops were quartered in Barnard Castle, before moving on to Richmond, then York, returning to Barnard Castle a mere five days later to pay his troops.

Piercebridge.

He stated on 28 February, 'in the morning all my soldyers payd their quarters in Barnard Castle' and he headed back to York in early March. He stopped off in Barnard Castle again a few days later as he headed to Northumberland while his troops mustered in Staindrop. He continued to patrol in the north, regularly visiting Barnard Castle and even stabled his racehorses there. In April he was at Gatherley Moor Racecourse where he 'tooke his meare and let her ride' and with some success, he comments 'Major Smithson wone the plate & my Meare came second'. He then headed to Caldwell.

For the next few months he was supporting manoeuvres in the north until a Scottish army, led by the Duke of Hamilton, crossed the border in July. The Parliamentarians were engaged in several sieges throughout the country and were unable to prevent the Scots taking Carlisle. The Scots, around 12,000 strong, marched south in support of King Charles. General John Lambert's Parliamentary horse were based at Penrith Castle and though not strong enough to fight the invaders, they would use their agility and skill to gain time until they could meet up with Oliver Cromwell. Lambert retreated ahead of the Scots down the Stainmore Pass. Appleby Castle fell on 31 July but he continued to block their route into Yorkshire and prevent any link-up with other Royalist forces besieged at Pontefract Castle. Sir Marmaduke Langdale's Royalist horse was unable to break through Lambert's cavalry screen and reconnoitre the situation behind his lines, so unsure of what lay before them.

Major Sanderson records the advance of the Scots to Appleby as he set off to support and meet up with Lambert at Bowes. He then manoeuvred between Bolam, Piercebridge and Wycliffe, before ending up at Egglestone Abbey on guard. There is also mention of a stand-off between Lambert and Langdale's horse at Gatherley, but Langdale backed off, probably with uncertainty at the size of the enemy before him. Sanderson continued to support Lambert and crossed into Yorkshire to meet Cromwell before heading to cut off the Scots in Lancashire. The Scots were strung out from Lancaster to Skipton and oblivious of the approaching Parliamentarian army until they finally clashed on 17 August 1648 at the Battle of Preston. The Scottish army was scattered and Sir Marmaduke Langdale escaped to Nottingham, only to be captured while resting in an alehouse. The Duke of Hamilton surrendered to Lambert at Uttoxeter on 25 August. Sir Marmaduke Langdale was later brought to trial, found guilty of treason and beheaded at Westminster on 9 March 1649. At the end of this conflict Charles I was executed following a trial conducted by Parliament.

During his time in the region Sanderson mentions on February 21, 'I quartered my troope in Barnard Castle and on 22nd headed for Richmond before going to York on the 23rd.' He returned to Barnard Castle via Leeming on the 26th and stayed until the 28th where he comments 'in the morning all my soldyers payd their quarters in Barnard Castle' but not a word about where the quarters were. He travelled from Northallerton on 5 March back to Barnard Castle and on the 7th paid for some oats and hay before setting off for Newburn (Tyne Valley). On the 11th after a round trip of Northumberland, he headed back to Hedleythorpe and on to Barnard Castle with his soldiers mustered at Staindrop 'consisting of 77 private soldyers' not including

lieutenants. On the 17th they headed for Hunwick, just north of Bishop Auckland, before heading back to Barnard Castle on the 18th. His soldiers were paid on the 21st and he headed to Woodham Moor, near Newton Aycliffe, but returned to Barnard Castle that night. After receiving new orders from Colonel Lilburne on the 23rd, he gathered supplies and left his racehorses in the care of a Richard Robinson and John Jackson – 'five pounds for to keepe my racehorses' – before marching with his troop to Lanchester on the 28th. On 17 April he returned from Hedleythorpe to Caldwell, where his horses were kept, and found his grey was lame and would not be able to run the next day as he intended. He headed for Gatherley near Scotch Corner on the 18th, then a racecourse of some note, where his mare came second to Major Smithson from Moulton Hall near Richmond, whose horse won the plate. He returned to Caldwell to again keep his horses with John Jackson. He called in at Caldwell again on the 21st, where he mentioned his racehorses were to go to Barnard Castle.

Cromwell visited Barnard Castle and Blagraves and General Lambert and his cavalry in July 1648.

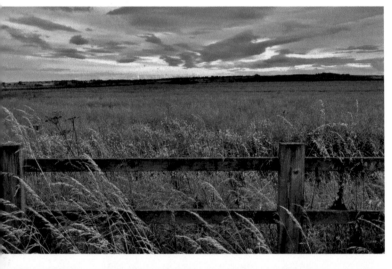

The countryside around Gatherley Moor.

Cow Green Reservoir now controls the river's flow from Upper Teesdale.

T

Tees River

The River Tees sweeps down the dale which takes its name, though the name Tees may derive from the old Celtic word 'tēs' meaning 'warmth', as in 'boiling, surging river'. The river originates from a high point in the Pennines and gathers tributaries along its route, passing the towns and villages of Middleton, Mickleton, Romaldkirk, Cotherstone, Barnard Castle, Winston, Gainford and Piercebridge, until arriving at the larger towns of Darlington, and eventually Stockton and Middlesbrough. In 1892, Arron Watson described his journey to the source of the Tees: 'Cross Fell was grey and cloud like, as seen in the morning sunshine, from where our pair of horses

High Force.

Low Force.

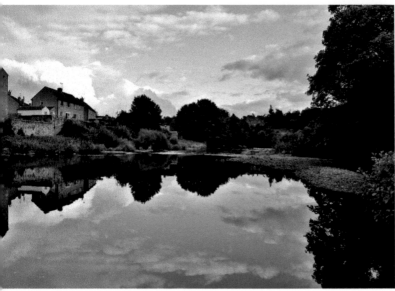

The Tees at Barnard Castle.

finished their journey at the Green Hurth Mines. The intervening space of undulating moor was as parched and brown as if some sudden flame had swept across it; and where the clouds moved slowly across the grey-blue of the sky, long bands of dark shadow fell, so intense as to lend the brightness of contrast to what otherwise might itself have seemed to be a mass of shade.' He continues, 'a white gleam of water in occasional hollows of the hills indicated the sluggish beck which divides Durham from Cumberland; and to the left, in a winding course well marked by the depression of the moorlands, the Tees wandered towards Caldron Snout'. He also records how on dry summer days it is 'but a thin and narrow stream' and when it rains 'it broadens and swells with an amazing suddenness, rushing down wards with a great roar and tumult of waters'. He also recants a tale he must have heard from the locals that unsuspecting visitors had 'been carried headlong over the terrible cataract of High Force' by these floodwaters.

The waters of the Tees are supposed to be the best in England for dyeing, and the goods manufactured here obtain the highest prices in the London Market on account of the brilliancy of their colours.

Rivers of Great Britain, 1892

In the flood of 1771, water penetrated into the cellars occupied by a dyer who still had a few pieces in the kettle, receiving their last process. The dyer did not risk life to save them. After the torrent had subsided, the man visited the kettle and removed the sand and mud, to find the pieces had attained a colour beyond his expectations. The articles were sent to London, and were so successful that orders were placed for more in the same shade. The dyer failed with every attempt to achieve the same colour without the 'genius' of the river.

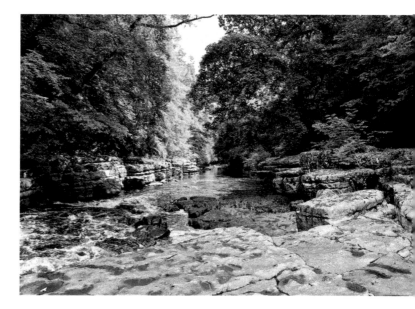

The Tees at Abbey Bridge.

Immortalised by JWM Turner at the 'Meeting of the Waters' – Greta into the Tees.

Upper Teesdale Industry

Described as one of England's most special places, Upper Teesdale is officially considered an Area of Outstanding Natural Beauty (AONB) and is a UNESCO Global Geopark. This part of the North Pennines is a spectacular landscape of open heather moors and peatlands, upland rivers and streams, grassy dales and meadows, beautiful wooded areas and good evidence of an industrial past. The distinctive geography of the area is very much visible in the landscape with waterfalls, sheer walls of whinstone and glacial features throughout. The flora and fauna are also very characteristic to the area with some birds, animals and plants being of significant interest.

The area encompasses Baldersdale, the Tees valley past Middleton-in-Teesdale, up towards Alston and north-east towards Hamsterley. Though now given the identifier of 'natural', there is a considerable influence of man, including the cluster of reservoirs on the rivers Lune and Balder, with another on the Tees at Cow Green further upstream. Much of the landscape has been fashioned by the mineral extraction from the dale since Roman times but with the increased activity during the Victorian era. Farming has also changed the landscape from natural, with dry stone walling, and well-kept pastures of moorland maintained by grazing sheep. Game shooting also means that the landscape is managed and the heathland is kept under control.

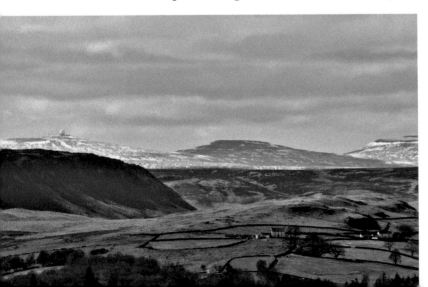

Upper Teesdale.

Holwick Scar,
Upper Teesdale.

Upper Teesdale –
walking country.

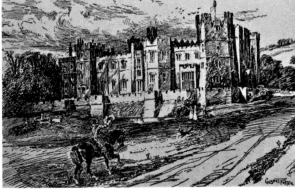

Above left: Part of the mill complex at Startforth. (Parkin Raine Collection)

Above right: Raby Castle. (Parkin Raine Collection)

Vane Family

One of the most influential families from the region is the Vane family, whose legacy and impact is still felt to this day.

It is thought the Vane family originated in Wales and there was a Sir Henry Vane knighted by the Black Prince at the Battle of Poitiers in 1356 who was the twelfth in descent from Howell ap Vane. A Sir Ralph Vane was knighted by Henry VII at the siege of Boulogne and he left no issue, so his estate descended to a brother called John Vane. The family seems to have settled in Kent and it was a Sir Henry Vane (1569–1654) who rose to be a principal Secretary of State to King Charles I and acquired a considerable amount of land in County Durham including Raby Castle.

Raby Castle and its lands had been part of the famous Neville family estates, but it was Charles Neville, 6th Earl of Westmorland, who along with Thomas Percy, Earl of Northumberland, had conspired in the rebellion known as the 'Rising of the North'. They had supported Mary, Queen of Scots in a shambolic rebellion of 1569, ending with the Earl of Northumberland being executed in 1572 and Charles escaping to Holland where he died in poverty in 1601. The castle and its lands were forfeited to the Crown and it was not until 1626 that Sir Henry Vane purchased Raby, Barnard Castle and the estate for £18,000. He chose to make Raby his principal home and therefore de-roofed and removed stone from Barnard Castle to repair Raby.

Raby Castle, Staindrop.

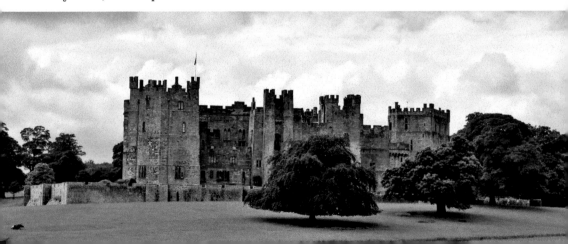

Vane helped create the deadlock that led to the dissolution of Parliament by Charles. In 1641 Vane helped bring about the impeachment and execution of the king's chief minister, Thomas Wentworth, the Earl of Strafford. As a result, Charles dismissed Vane from office and he ended up working for the Parliamentary cause during the Civil War. He continued to sit in Parliament but because of opposition to their policies, he took a less active part in proceedings. His son, Sir Henry Vane the Younger, was a Protestant and governor of one of the newly established colonies until he became disillusioned with some of the rigid dogma of the religious groups. He returned to England where he was involved in the Civil War against Charles I but was also opposed to the execution of the king and was persecuted by the Cromwell dictatorship. In 1656 he was briefly imprisoned for publishing a pamphlet attacking Cromwell's protectorate and helped the army overthrow Oliver's son in 1659. Following the restoration of the monarchy he was sentenced to death by King Charles II and was executed in 1662 for his past Parliamentary activities. The king deemed him to be 'too dangerous a man to let live' and on the scaffold his speech was deliberately drowned out by trumpets and drums. He gave a copy of his speech on paper to his friends for later publication before laying his head on the block and died 'as much a martyr and saint as ever man did', according to Pepys.

Christopher Vane succeeded Henry the Younger and was MP for County Durham from 1675 to 1679 and for Boroughbridge from 1689 to 1690. After the 'Glorious Revolution' in 1688, where the Catholic James II was ousted from power, he was made a privy counsellor, and in 1698, was created Baron Barnard of Barnard Castle by William III. Henry, the 3rd Lord Barnard, was created the Earl of Darlington in 1754 and restored the castle, with further work by his son in 1768. The 3rd Earl, William Henry, was created Duke of Cleveland in 1833 and his son Henry began another period of rebuilding in 1843. Over the next ten years he converted the south-facing round tower into the magnificent Octagon Drawing Room. The Vane family still own the Raby Estate, with the 12th Lord Barnard and his family still the incumbents of this glorious castle and jewel of the dale.

Memorials to the Vane family in Staindrop Church.

Witham Hall Winch Bridge

The Witham Testimonial Hall

This building is a memorial to Henry T. M. Witham, the noted geologist, intellectual and benefactor to the poor or 'Labouring Classes of Teesdale', who passed away in 1844.

The Victorian age brought many benefactors to the poor, mainly from industrialists who amassed great wealth or intellectuals from good families. These philanthropists, morally or intellectually, wanted to give back to a society that was hugely divided between poor and rich. In 1835 a Dispensary Society was set up in Barnard Castle, with a fund to provide medical advice and medicines to those that could not afford to pay for medical services. These funds were donated by the more affluent families among the dales population and the first society was a rented space above a grocer's shop in the town. Henry Witham was a keen supporter of the fund and became its president in 1832, even though he had already founded a Mechanics' Institute to provide education and pleasure activities for the labouring classes in the little spare time they had.

There were deep suspicions among the middle classes, who were not necessarily in favour of funding the lower classes. However, Henry Witham's persistence and strenuous efforts meant he managed to organise helpers and subscribers, and within seven years the institute owned 450 books, equipment, working models for demonstrations – and all this without an official institute building to meet

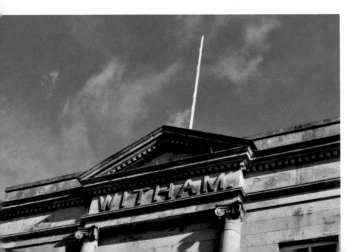

Witham Hall.

in. In early 1844, Henry Witham felt it was time to get an official home for his institute and the Dispensary Society, so a public meeting was called where £750 was raised. Then the town held a bazaar, which brought in another £1,000, with a further £240 donated by the Dispensary Society if it could be housed in the new building. Disaster struck in 1844 when in November Henry Witham passed away and the building was left incomplete. The public subscriptions meant the Witham Testimonial Hall was built in 1845–46 to the designs of John and Benjamin Green. The opening ceremony was held on 27 April 1846 and was marked by a bazaar and an exhibition of paintings.

The building consisted of a large upstairs meeting room for public meetings, demonstrations or lectures. On the lower level were the library, reading room and the dispensary in the room to the right of the entrance. In the yard at the back of the building was a cottage to house a paid librarian. Soon it was clear that a larger building was required and in 1860, a music hall was constructed to the rear at a cost of £807. This opening was marked by a day-long event and a concert in the evening

Hall Street, to the side of the Witham Hall.

and it is thought the new building was accessed from the rear of the Testimonial Hall via an uncovered footpath. This building used to hold concerts, dances, operas and magic lantern shows. It is thought the linking corridor was added in the twentieth century and incorporated parts of the earlier structure. The librarian's cottage was demolished in 1980 and the corridor was removed in the extensive renovation of the building in the early part of the twenty-first century.

The Mechanics' Institute flourished and by 1869 had a library of over 2,000 books. The building's rooms were being well used by various organisations, so much so that a paid agent was employed to manage the heating, letting and ventilation. Over the years the uses of the Witham Testimonial Hall changed, with the government taking over some of the institute's aims with the Public Libraries Act of 1850 and then the Education Act of 1870, but the impact of the Library Act was very slow and as late as 1947 the Mechanics' Institute still housed Barnard Castle's lending library. It was not until 1954 that the hall's lecture room became the county library, which is still attached to the hall to this day.

By the mid-twentieth century the Witham complex functioned more like a town hall, accommodating official and social events. Elections were held here with results being announced from the upper windows and new kings or queens proclaimed from the steps of the hall. During the Second World War the hall was where the evacuees from Tyneside were brought to the town for gas masks to be fitted and ration books to be issued. It was also considered the central hub and meeting place for any important war news. After the war the hall was used as a private auction house by a private company for a significant period.

In 1981, Barnard Castle Town Council took over the running of the building and the YMCA moved into Witham Hall until the formation of the community association. Today Witham Hall hosts many events and is still very much a part of the community as an entertainment facility, meeting place and library.

The Witham Testimonial Hall is the largest memorial in Teesdale and still honours the life of a most honourable and charitable man, Mr Henry Witham Esq. of Lartington Hall.

Winch Bridge

The Winch Bridge is said to be the earliest suspension bridge in Europe (1741) and was originally used by the local lead miners to cross the Tees to get to the lead mines on the other side. Positioned at a narrow ravine, the original bridge was suspended on hand-forged wrought-iron chains, and had only a single handrail on one side as support. This bridge collapsed in 1802 when a chain broke and a man lost his life in the turbulent water below. The bridge was replaced in 1830, financed by the Duke of Cleveland, but its maintenance was paid for by the miners' subscriptions. The bridge was strengthened in 1992 and is Grade II listed.

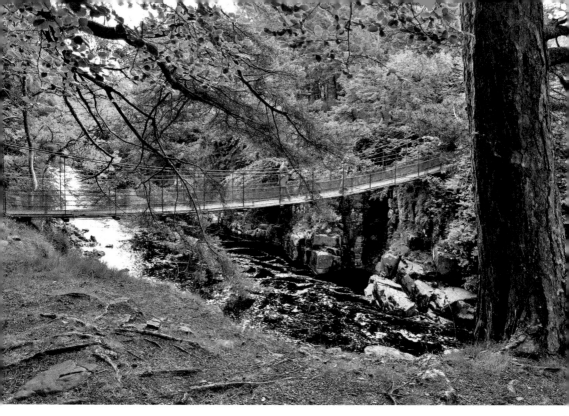

Winch Bridge.

Local history enthusiast Cynthia Mackenzie gave us this family photo below and explained 'it was possibly taken by my Grandma Annie Shield who lived at Cottage Farm in Holwick. Her Mother told the story of the miners being winched over the bridge. She was alive until I was aged six and she lived with us. The Shield family were in the village from the very early 1700s and possibly before.'

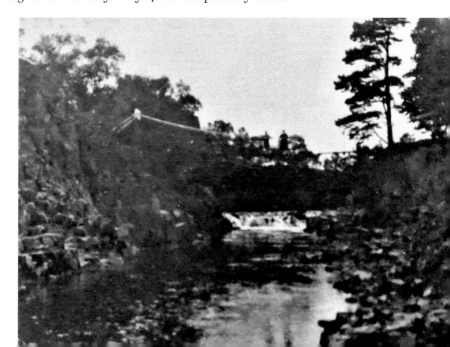

Family photo of Winch Bridge. (Courtesy of Cynthia Mackenzie)

Xtra Stories from the Dale

1804 – A Teesdale Volunteer, William Dent, was fined the sum of twenty shillings for not restoring his arms in good condition after resigning. This confirms the Volunteers were still active in 1804.

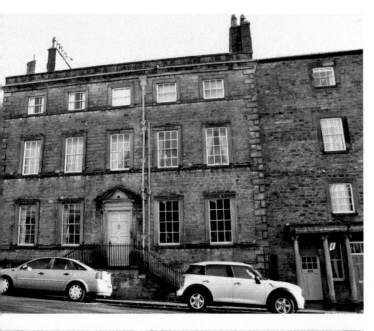

Residence on Thorngate used by judges on the circuit.

IN 1796 THIS HOUSE BECAME THE RESIDENCE OF SIR JOHN HULLOCK, KNIGHT AND BARON OF THE COURT OF THE EXCHEQUER. HE ENLARGED IT TO ACCOMMODATE AND ENTERTAIN HIS FELLOW JUDGES WHILE ON CIRCUIT.

Descriptive plaque on the residence on Thorngate.

1814 – Robert Harden was charged with travelling with his wagon on a Sunday, with the churchwardens being notified. He confirmed he would not offend again and he was not convicted.

1811 – William Cust, who lived on Horse Market, was a plumber with an apprentice called Thomas Ewbank. The apprentice claimed ill-treatment and both parties were brought before the justices, who ordered the apprentice to return to his master and be employed from 6 a.m. until 8 p.m. in no other role than that of a plumber and glazier. He did not need to clean his master's shoes or tend to the horse employed in the business. If any of these conditions were violated the apprenticeship would be cancelled. The Ewbank family went on to build a number of houses on King Street.

1817 – In January, on three separate nights, three corn stacks in Cotherstone were pulled to pieces and the top of the haystack thrown down. The defendants – William Chapman, Robert Gargett and William Stabler – said the haystack had not been thatched and was blown down. The complainant was Alexander Stevenson, the parish constable, who said the defendants had conspired to do him an injury because of the discharge of his public duties in the execution of certain warrants from his majesty's justice. The constable had to convey to court the aforementioned William Chapman and one Paul Armstrong to prison, both charged with 'driving' offences. Much evidence was given but the fate is unknown.

1818 – Thomas Precious of Bishop Auckland who was convicted of driving his Exmouth coach furiously down Station Bank and overturning the cart of Joseph Garnet, endangering his life and the lives of others. Also convicted was Henry Elwood, for driving the Telegraph coach. The two coaches were racing each other on 3 of January. Both men were fined £5 each.

1818 – Three pauper boys apprenticed to a hatter, a shoemaker and a painter and grazier were not paid for their work and therefore this was considered slavery.

Below left: Plaque in Horsemarket.

Below right: Market Cross at times was used as a lock-up. (Parkin Raine Collection)

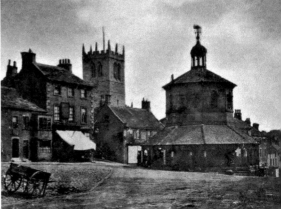

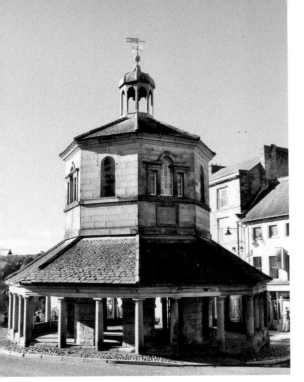

Above left: Market Cross today.

Above right: Stone plaque on the wall of an old public house in Laithkirk.

1875 – The *Teesdale Mercury* reported a band of 'negro minstrels' performed a selection of 'characteristic songs and glees' at the Ancient Foresters, Court St James No. 381 in Barnard Castle and later that year also performed in Middleton-in-Teesdale. They were followed by a party of grotesque Shadow Dancers, ably conducted, and whose gambols caused considerable merriment.

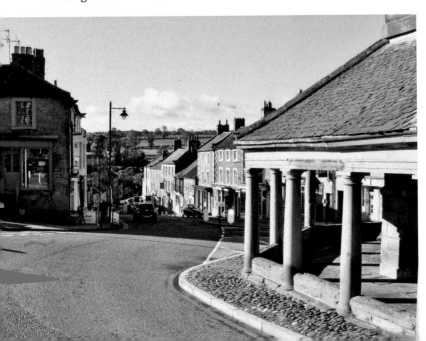

The Bank in Barnard Castle.

Y

Young Troops of the Teesdale Volunteers

The Teesdale Volunteers, or Legion as they were more commonly known, were formed as a kind of 'home army' to defend Teesdale against the threat of a French invasion during the Napoleonic Wars of the late eighteenth and early nineteenth centuries. They were made up of volunteers from all across Teesdale, young and old, from all classes and different walks of life. Each volunteer was issued with one musket, a knapsack with three days' worth of food and sixty rounds of ammunition.

Beacons were built right across the county, including Teesdale, and were to be lit in the event of 'Old Boney' (Napoleon) invading. In February 1804, the beacon on Langley Fell was accidentally lit and the volunteers of the Legion, consisting of both men and boys, gathered on Market Place in Barnard Castle. With every village and town of the dale represented, they were ready to fight to keep Teesdale safe from the French. The false alarm didn't worry the volunteers as with great relish they took to the inns and taverns of Barnard Castle instead.

Below left: Old photo of the Teesdale Volunteers. (Parkin Raine Collection)

Below right: An old volunteer. (Parkin Raine Collection)

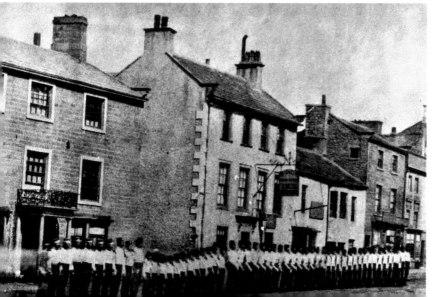

A poem about the Teesdale Legion was written after the false alarm, where nearly 1,200 volunteers were raised. It was once performed in the Old Moot Hall, which was the old town hall before the construction of the Market Cross. An amateur performance group often met at the Old Moot Hall and on a Wednesday evening in late February 1804 the poem was performed for the last time by a Mr Prudah of the Deepdale Mill.

The Teesdale Legion
The colonel brave from Rokeby Hall
Is first to rise at duties call
Then Greta, Thorpe and abbey old
Gather their Yeoman blithe and bold
Streatlam levies it's chosen sons;
Cleatlam never conflict shuns;
Naby from its fields & flowers
Raby from its ancient towers
Newsham from its murmuring rills
Barningham from its heath-clad hills
With hearts elate to do and dare
Send their champions to the war
From Gainford see them pressing on
From Winston and from Ovington
Hutton & Wycliffe from their trees
From Mortham Scargill, Brignall too
They haste away from fold and plough
Whorlton, Barford, Caldwell, all
Promptly answer the bugle call
Stainton, Westwick instant arms
And hail them forth from field and farms
Stalwart men from rural Marwood
Miners strong from distant Harwood
Troops from Staindrop merrily come
Marching lightly to the beat of the drum
And stoutly with the foe will cope
Old Boldron, Gilmonby and hope,
Startforth and Bowes with lion heart
Will firmly act their noble part
And Kilamondwood and Rutherford
have never bent to an alien Lord
Where the Tees runs in its mountain course
Forest and Langdon raise their force,
Newbiggin and Bowlees join the throng,
Middleton and Holwick march along

Mickleton, Lonton, Wemmergill
call their sons down from dale and hill
Eggleston and Hunderthwaite
were never to the fray too late
From Romaldkirk they march with glee
Cotherstone moves with the step of the free,
Cragg and Lartington from afar
Have heard the summons to war
Hearts as bold will comrades hail
From Lundale and Baldersdale,
Cockfield, Ingleton, Wackerfield
To a foreign yoke will never yield
Langton and Selena give place
To none who danger seeks to face
Woodland, Copley, Butterknowle
Defiantly their flags unfurled
Bleak Barony and Evenwood
Now swell the patriotic flood
And Keverston And Headlam burn
With zeal the despot to O'er turn
Lynesack and Softly from the height
And Langleydale rush to the fight
and stately The Baliols sons advance
To quell the arrogance of France
Their banners in a winters breeze
float gaily along the banks of the Tees
'when roused, restless!' is the boast
of that Teesdale Martial host
Gathering from hill, vale and moor
See our valiant soldiers pour
Assembled now in Bernard's town
soon they depart to fresh renown
With ardour all their bosoms glow
To measure weapons with the foe
Inspired with honourable pride
Defending his each own fireside
His wife his child all that is dear
All that life on Earth can cheer
Go then to the Fields of Glory
Where your sires marched before ye
Scorn the haughty oppressors' chains
Tell him his threats are vane

That English men have hearts of steel
Fighting for their countries seal
and that should it be heavens decree
That they should die for Liberty
They know that on their native shore
Their name will live for evermore
Impressed on England's brightest page
Their names to be read from age to age.

Fortunately, that great old barrier to invasion, the old 'General Channel' (English Channel), stopped Napoleon in his tracks, along with a little help from Lord Horatio Nelson's wooden wall in 1805 at the Battle of Trafalgar, but you cannot help thinking, Napoleon would have been in for quite a fight had he arrived in Teesdale.

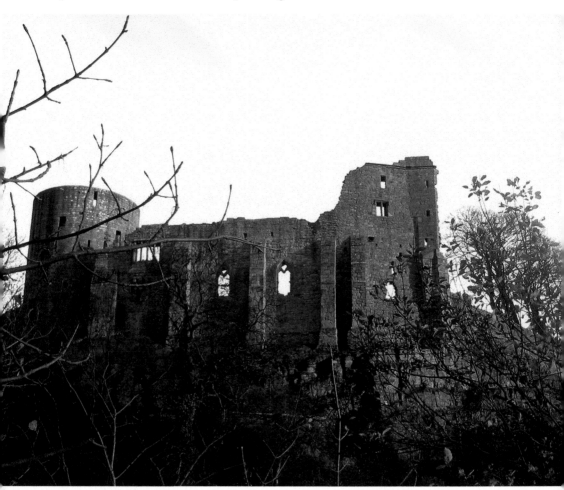

Barnard Castle from the south.

Z

Zetland

Zetland is an old name for Shetland and until 1974, following the county border changes, Shetland was officially known as Zetland. Sometimes more Scandinavian than Scottish, Shetland was annexed to Scotland in 1471 following a royal marriage and an unpaid dowry. Before this it was in the Norse sphere of influence and though there has been repeated attempts to have the islands returned, the privy council in Edinburgh did not agree.

The Teesdale connection comes from the Dundas family who reside at Aske Hall near Richmond. In 1794, Thomas Dundas was created Baron Dundas of Aske and was Lord Lieutenant of Orkney and Zetland, an MP for Richmond (1763–68) and an MP for Stirling (1768–94). He was succeeded by his eldest son, Lawrence, and after providing financial support to the Duke and Duchess of Kent, who were the future Queen Victoria's parents, he was created the 1st Earl of Zetland in 1838.

The family went from strength to strength, as the 2nd Earl of Zetland was a Knight of the Garter, Lord Lieutenant of the North Riding of Yorkshire and Grandmaster of the Freemasons of England. They were also owners of one of the greatest racehorses in 1850, Voltigeur, who won both the Derby and St Leger. Their star continued to rise

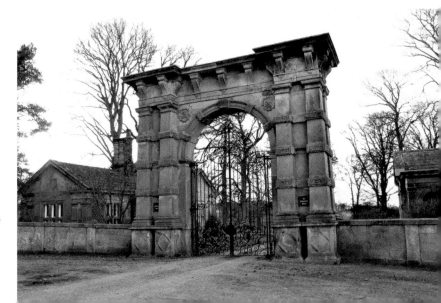

The old entrance to Aske Hall.

Memorial to Rear-Admiral Sir Christopher Craddock in Gilling West Church.

when the 3rd Earl of Zetland became the 1st Marquess of Zetland in 1892. The family continued to live at Aske Hall and held various public offices, with the current holder being Lawrence Mark Dundas, the 4th Marquess of Zetland.

The Zetland Hunt used to be known as the Raby Country Hunt, which was established by the 3rd Earl of Darlington (later the 1st Duke of Cleveland) in 1787 and covered a huge area of North Yorkshire and South Durham of around 20 miles square. The hunt had 'significantly diminished' by the time of his death in 1842 and his son, the 2nd Duke of Cleveland, continued with the hounds for another twenty years but gave up in 1861. It was in 1866 when the old Raby Country was re-established by Mr Christopher Craddock of Hartforth Hall, whose son was Rear-Admiral Sir Christopher Craddock, at his own expense. The hounds were kennelled at Hartforth Hall but in 1879, the Earl of Zetland bought the hounds and moved them to Aske Hall.

Lord Zetland remained the Master of the Hunt until 1910, and this period is considered the golden age of the hunt. When Lord Zetland gave up the hounds in 1910, it was decided that to commemorate his time as Master, the hunt would become known as the Zetland.

The boundaries of the hunt are from the River Wear running through Bishop Auckland, to the River Swale at Richmond, with the western boundary defined by the rising land towards the moors and to the outskirts of Darlington to the east. The Tees Valley is considered the best of the country, especially around Aldbrough St John, Gainford and Staindrop.

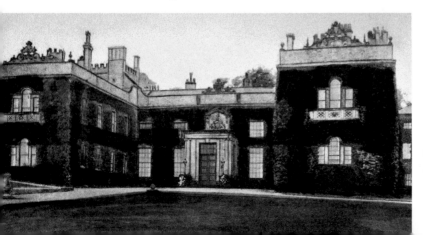

Old postcard of Aske Hall.

Zetland Road

After the Second World War, to the north-east of the town, Zetland Road was built as part of a council housing estate when municipal housing became part of the welfare system. The politics of the time felt it 'reinvigorated the sense that council housing catered predominantly for a relatively prosperous and aspirational working class'. A progress report from October in 1946 includes a letter from the architect stating that every effort was being made to speed up the completion of the fifty-four houses being built on Zetland Road. He pointed out that a skill shortage, especially in plasterers, was the reason for the slow progress of the scheme.

The *Teesdale Mercury* reported on 15 May 1946 that the North-Eastern Electric Supply Co. Ltd had received an order to supply fifty-four Jackson 95 deluxe electric cookers and fifty-four Burco electric wash boilers for the new council houses being erected by the North-Eastern Housing Association in Zetland Road on the Tenfields Housing Estate.

Egglestone Abbey near Barnard Castle.

Teesdale – a beautiful dale.

Bibliography

Court Roles, sixteenth century

Durham Records Office

From Jacobite to Radical: the Catholics of North East England, 1688–1850, Leopold
 Gooch, Durham theses, Durham University, 1989

History and Antiquities of the County Palatine of Durham, William Hutchinson

Historia regum Anglorum et Dacorum, Symeon of Durham

Major Sanderson's War, P. R. Hill and J. M. Watkinson, 2008

Notes of Revd A. W. M. Close, Stanhope Road, Darlington

Poems & Songs of Teesdale, Richard Watson, 188

Rivers of Great Britain, 1892

Teesdale Mercury Archives

The History and Antiquities of the County Palatine of Durham, Robert Surtees

The History and Antiquities of the County Palatinate of Durham, William Fordyce

The Terrier of the High Parish of Gainford, Allan Wilkinson

About the Authors

Andrew Graham Stables has written several books for Amberley exploring
the lesser-known histories of some northern market towns and cities. A keen
photographer and regular contributor to various online history groups, he has been
involved in a number of talks for various groups in the North East and contributed to
TV history shows.

Gary David Marshall is a local history enthusiast who has spent several years
investing the archives of the Bowes Museum and is the custodian of an archive of
old photographs from Barnard Castle and the whole of Teesdale. He is an active
campaigner in the fight to save the castle walls and other historical artefacts
throughout the region; he is also the main administrator of a 5,000 plus-strong
Facebook group dedicated to the history of Teesdale.